Sun Valley Images

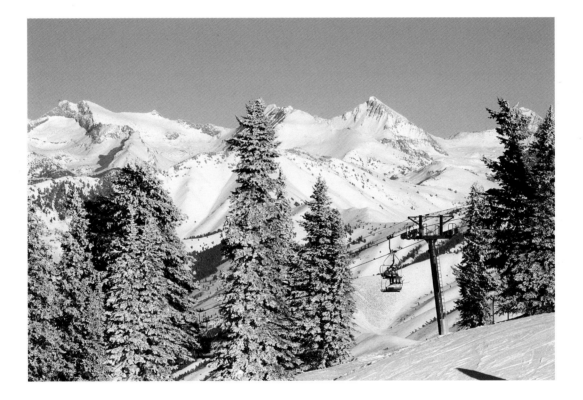

PHOTOGRAPHY BY DAVID R. STOECKLEIN

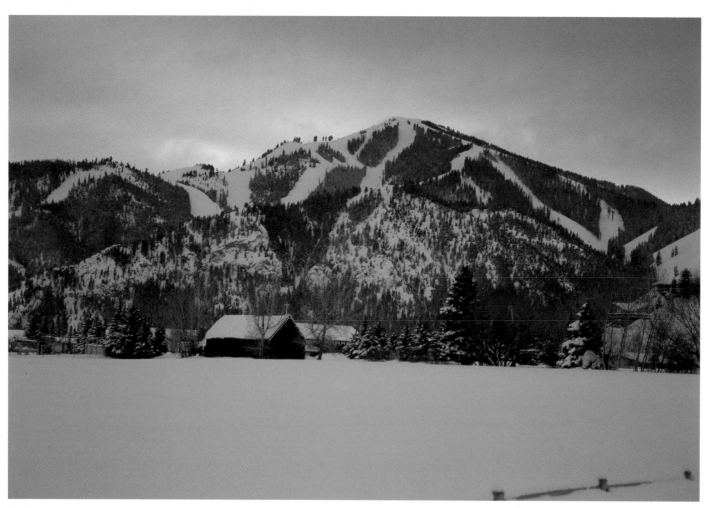

Sunrise
Bald Mountain from Bitterroot Road

This book is dedicated to my sons,
Drew, Taylor, and Colby.

—David R. Stoecklein

STOECKLEIN PUBLISHING

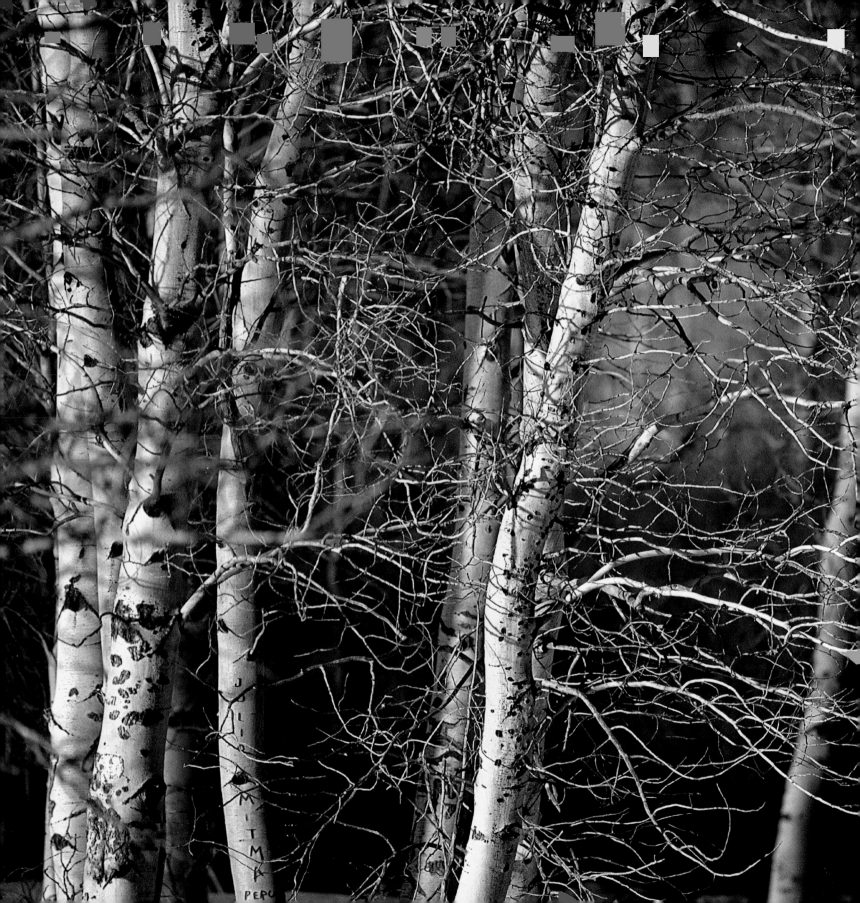

PHOTOGRAPHY DAVID R. STOECKLEIN

EDITOR CARRIE JAMES

ART DIRECTION & DESIGN T-GRAPHICS

Cover photo: Fresh snow—Bald Mountain from Trail Creek
Back cover photo: Aspen trees—Smoky Mountains
Inside cover photo: Challenger chair—Top of Bald Mountain

All images in this book are available as signed original gallery prints and for stock photography usage. Stoecklein Photography houses an extensive stock library of western, sports, and lifestyle images. Dave Stoecklein is also an assignment photographer whose clients include Canon, Kodak, Bayer, Hatteras, Marlboro, Chevrolet, Timberland, Ford, Wrangler, Pontiac, and the Cayman Islands.

Other books by Stoecklein Publishing include The Idaho Cowboy, Cowboy Gear, Don't Fence Me In, The Texas Cowboys, The Montana Cowboy, The Western Horse, Cowgirls, Spirit of the West, The California Cowboy, The Performance Horse, Lil' Buckaroos, Cow Dogs, The American Paint Horse, and Sun Valley Signatures I,II,III.

Every year, Stoecklein Publishing also produces a line of wall calendars, prints, and cards featuring the western photography of David R. Stoecklein. For more information or to request a catalog, please contact:

Stoecklein Publishing & Photography
Tenth Street Center, Suite A1
Post Office Box 856 • Ketchum, Idaho 83340
phone 208.726.5191 fax 208.726.9752 toll-free 800.727.5191
www.stoeckleinphotography.com

Published by World Publishing Services
2135 Wilder Street • Helena, Montana 59601

Printed in China

Copyright ©2002 by David R. Stoecklein & Stoecklein Publishing

ISBN 1-931153-23-X
Library of Congress Catalog number 2002094425

Winter aspens
Big Wood River north of Ketchum

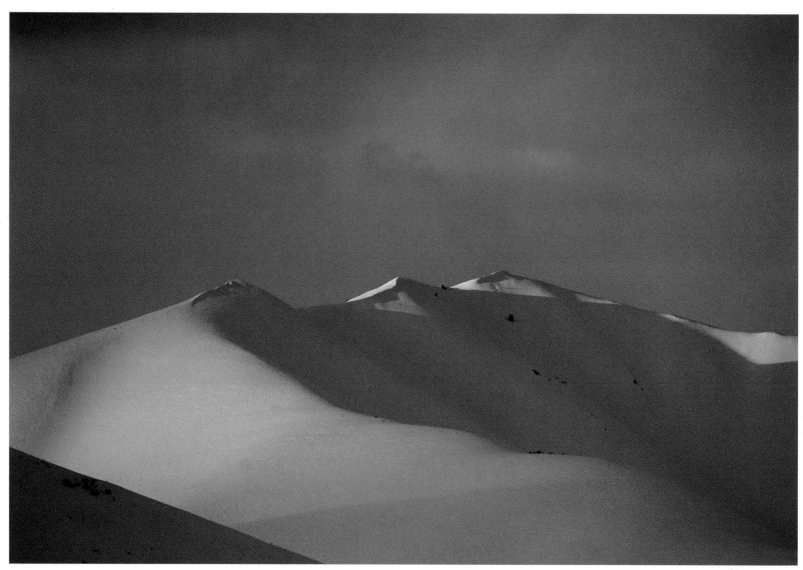

Sun Peak
Trail Creek Road

Introduction
by Carrie James

David R. Stoecklein moved to Sun Valley in 1979. The area's environment helped mold his vision and refine his ability to capture the outdoor lifestyle that is synonymous with Sun Valley. He is still struck by the spectacular vistas and the timeless beauty of his adopted home on a daily basis. This collection of images from David's archives captures the elusive quality of mountain life that so many of us find irresistible. The pages of this book will bring each reader on a wonderful journey through the varied terrain and seasons of this magical place—rugged mountains, high desert plains, alpine lakes, and roaring rivers. All of these elements change dramatically throughout the seasonal cycles and these photographs capture those qualities perfectly.

The images in this book demonstrate why the area has been a source of endless inspiration for so many writers, artists, athletes, and others. It is not merely about the town or the resort of Sun Valley, which has its own rich history. There is a certain hidden quality of life here that is unique and intoxicating. This book communicates the true essence of the place and includes a wide range of locations that attract so many visitors. It truly is an outdoor playground where people can hike, bike, camp, fish, ski, snowshoe, and kayak—all the while surrounded by unspoiled wilderness and natural beauty.

Photographs of brilliant sunsets, crystalline lakes, magnificent wildlife, and soaring peaks share the pages of this wonderful volume with images of individuals enjoying all that the area has to offer. Anyone who spends enough time here treasures the way of life that Sun Valley offers and works hard to preserve it. For those who enjoy the laid-back lifestyle and stunning beauty of a mountain town, or simply wish for a temporary escape from the normal routine, this book is an inspiration and a reminder of how lucky we all are that places like Sun Valley still exist.

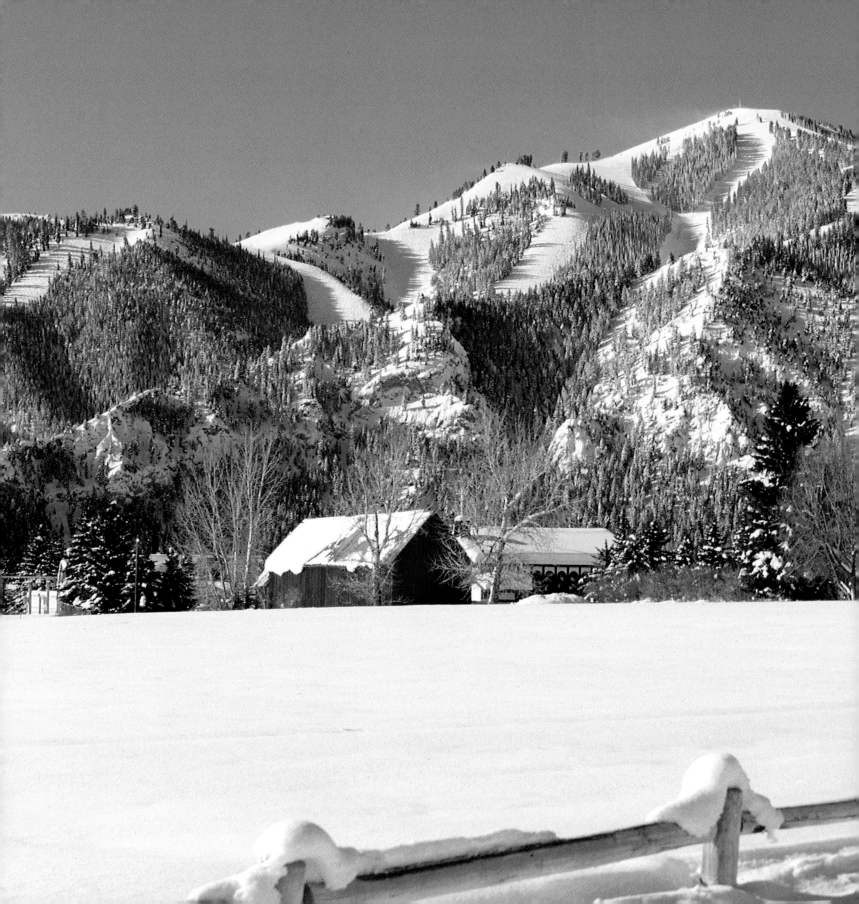

Winter

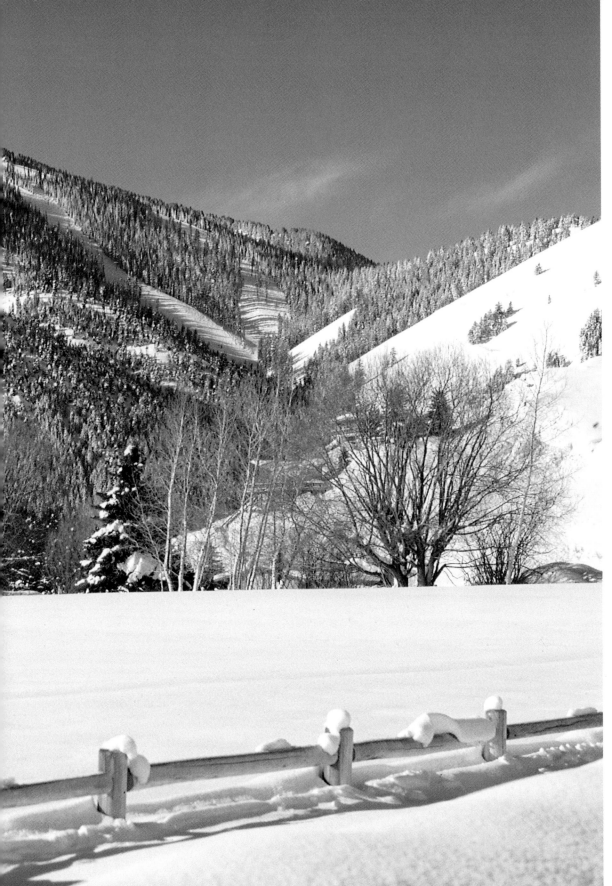

Fresh snow
Bald Mountain from Bitterroot Road

9

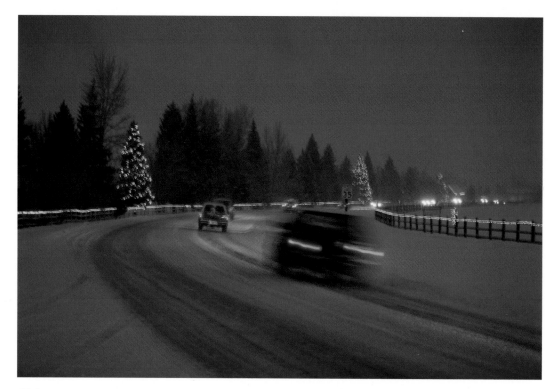

Christmas
Sun Valley Road

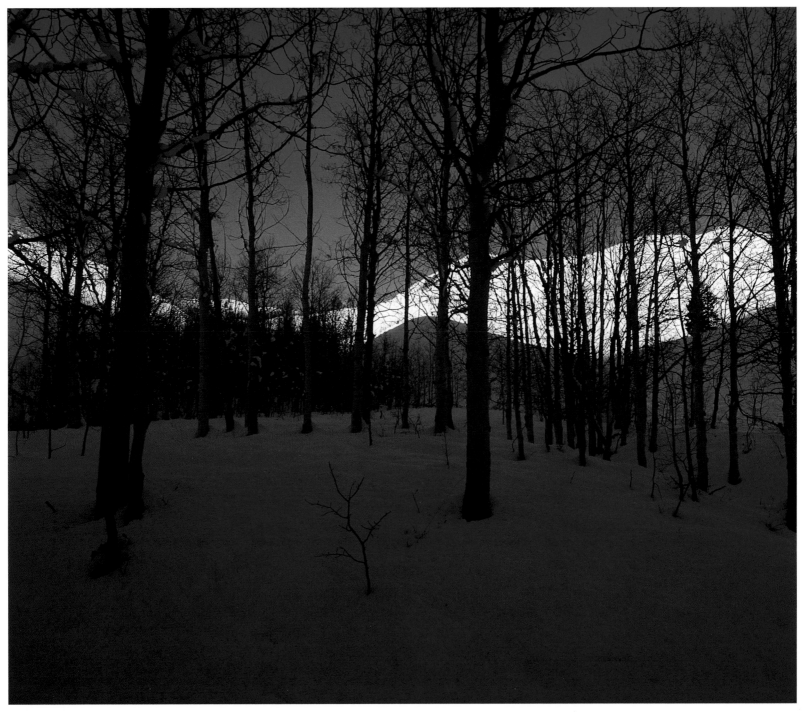

Adams Gulch

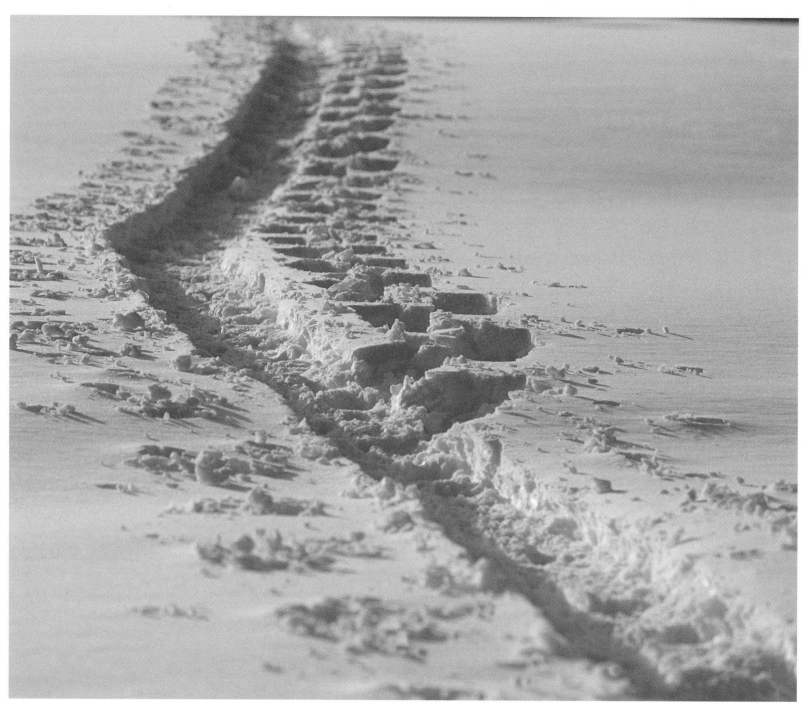

Snowshoe trail
Billy's Bridge

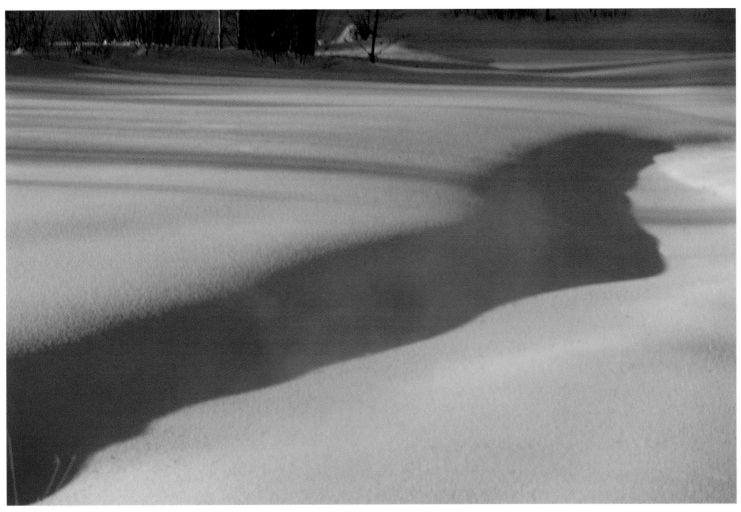

Frozen stream bed
Boulder Mountains

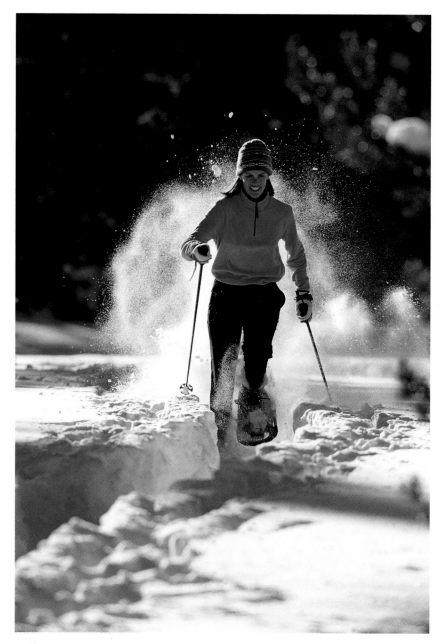

Katherine Rixon, snowshoeing
Billy's Bridge

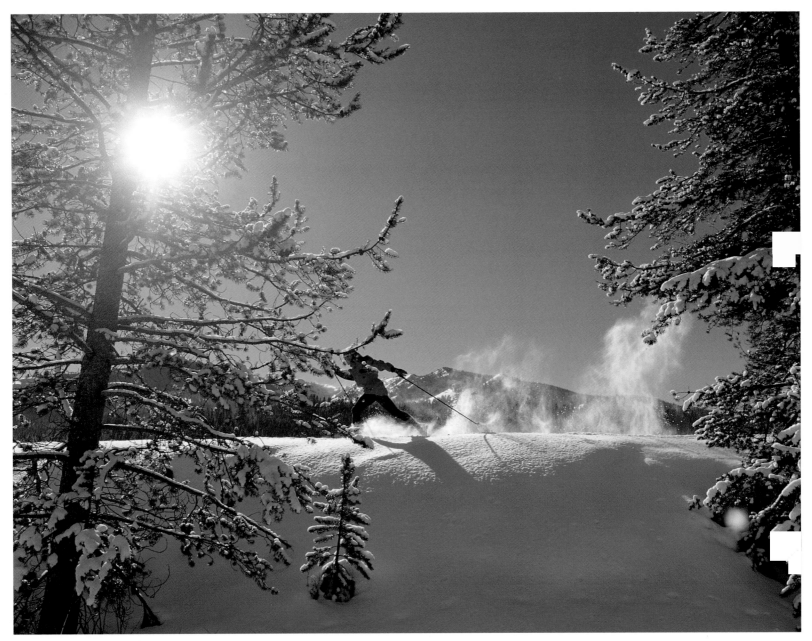

Adam Heaney, cross-country skiing
Billy's Bridge

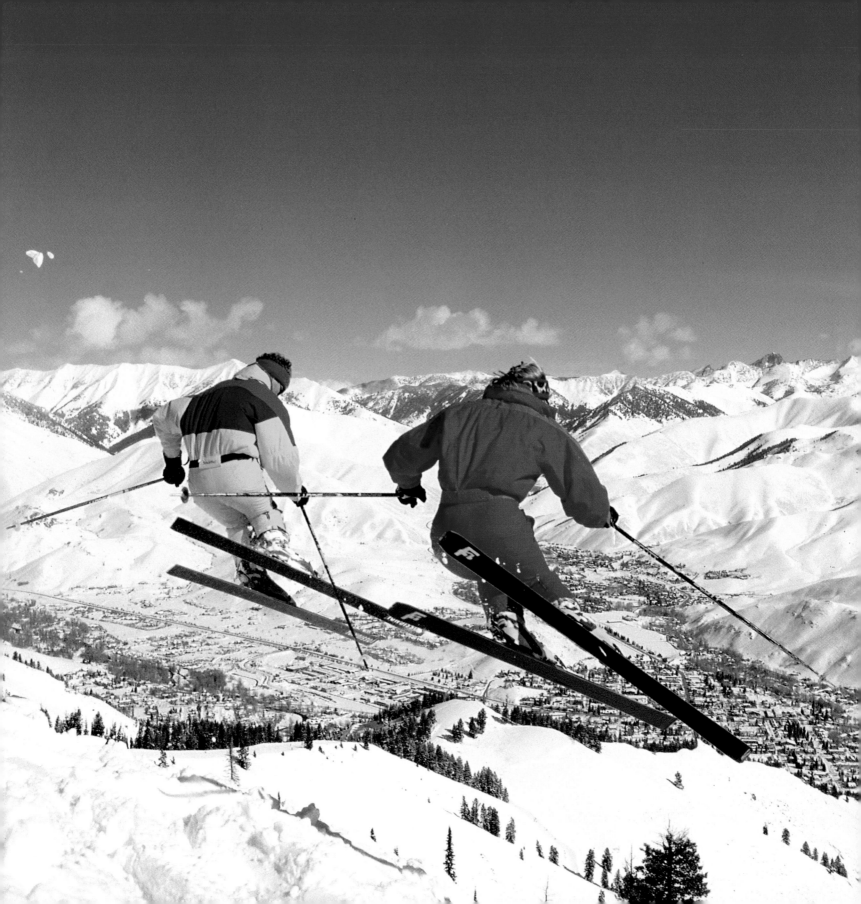

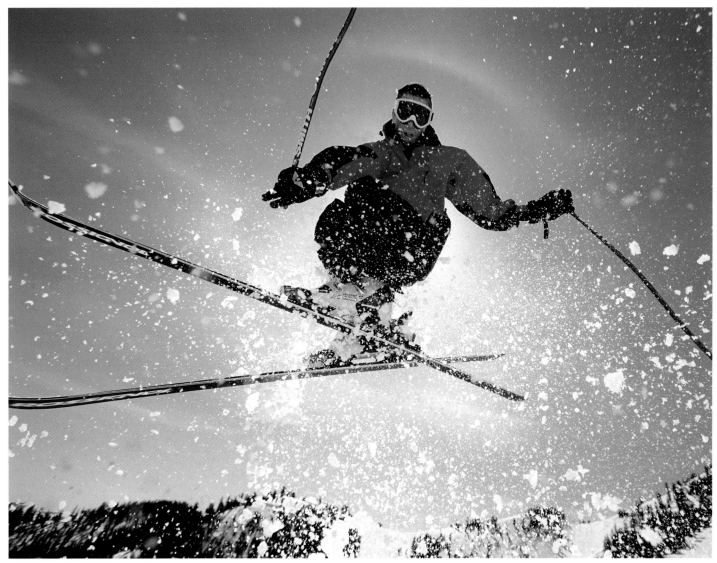

Drew Stoecklein
South slopes, Bald Mountain

Danielle Crist, Doug Fenn
Rock Garden, Bald Mountain

17

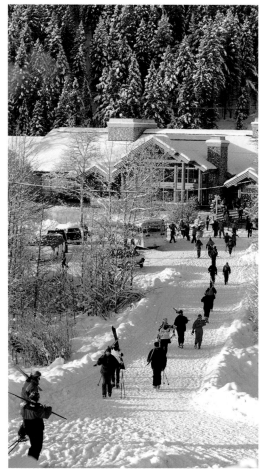

River Run Lodge

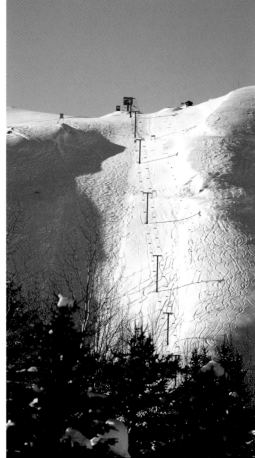

Dollar Mountain

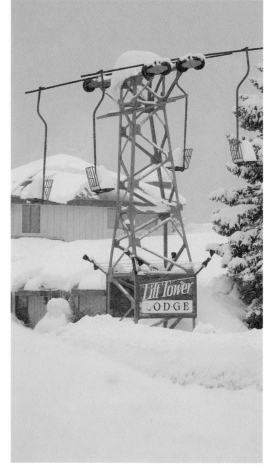

Lift Tower Lodge

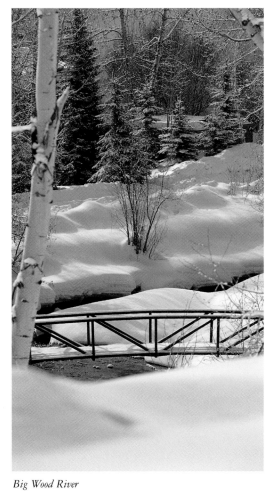

Big Wood River

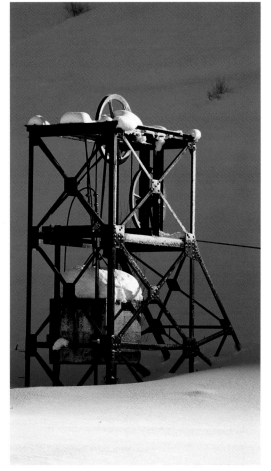

First chair
Ruud Mountain

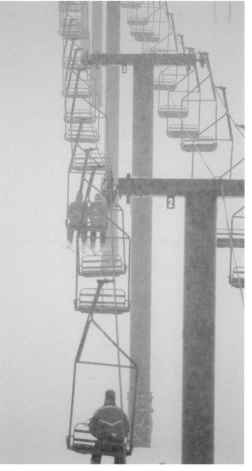

Foggy Day
Dollar Mountain

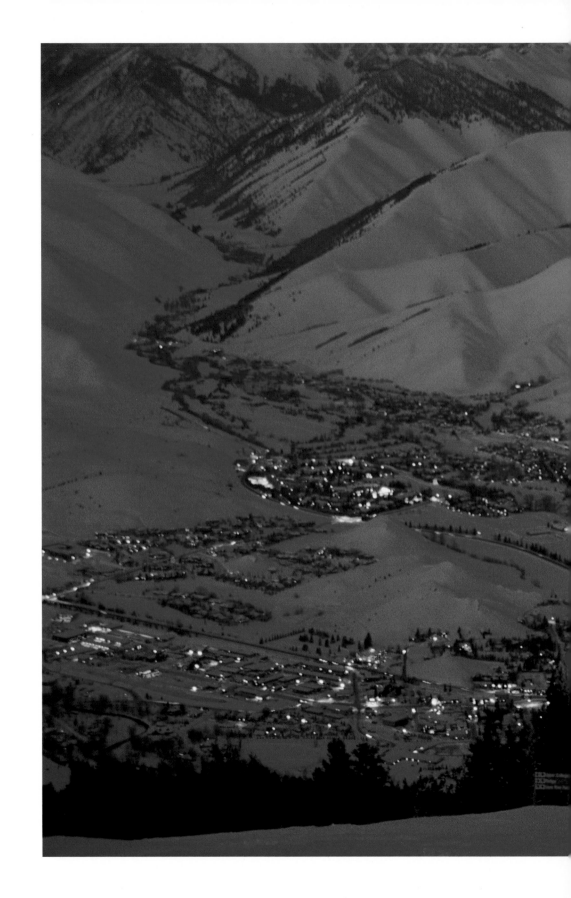

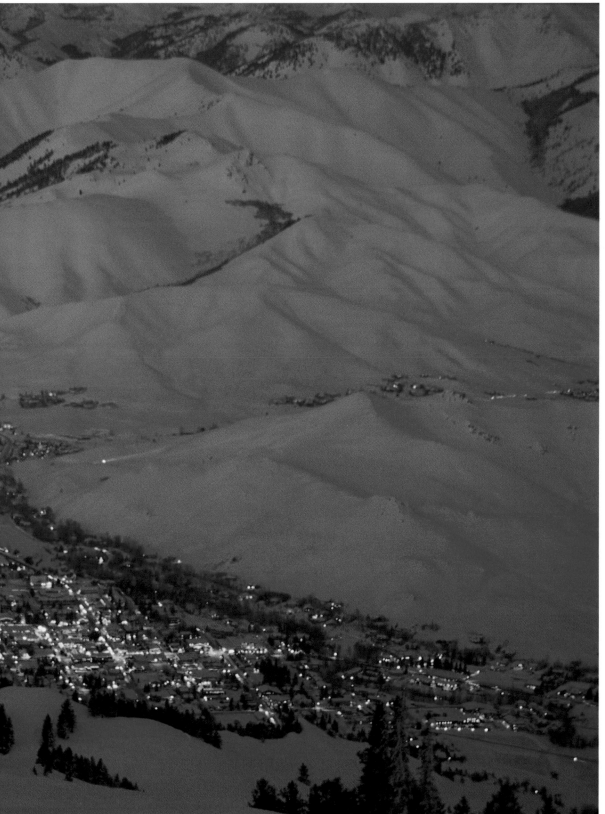

Ketchum at night
from the top of College

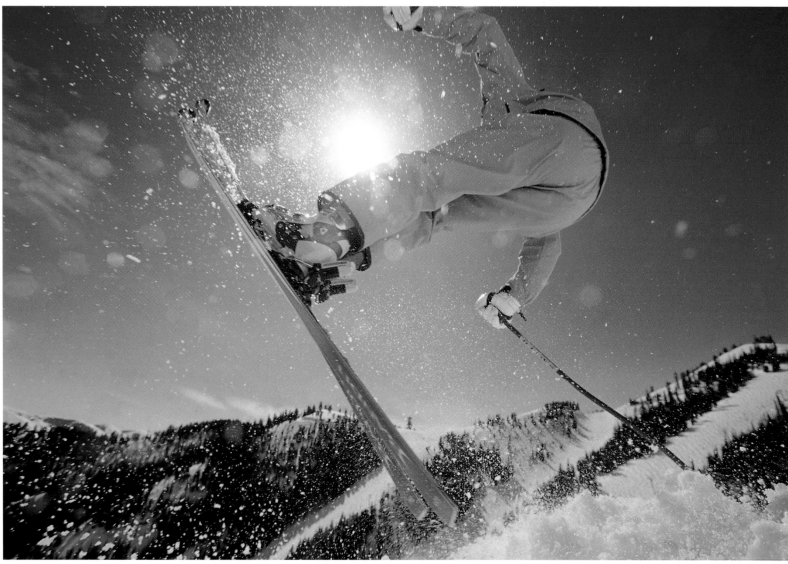

Shroder Baker
Bald Mountain

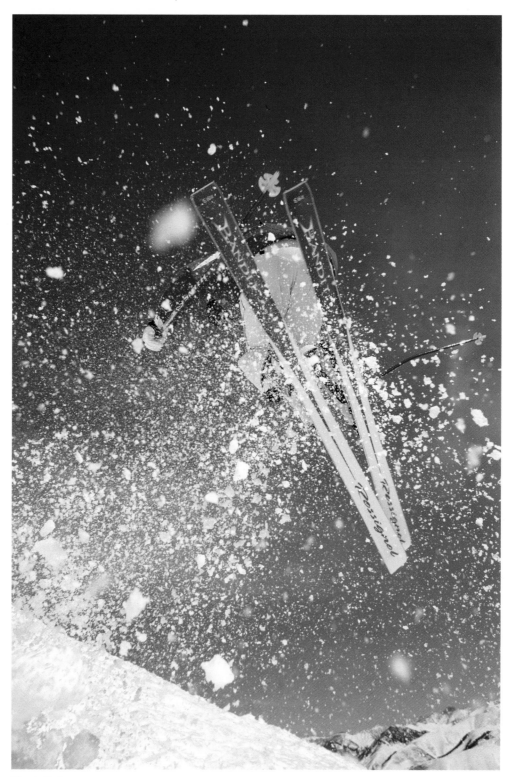

Shroder Baker
Bald Mountain

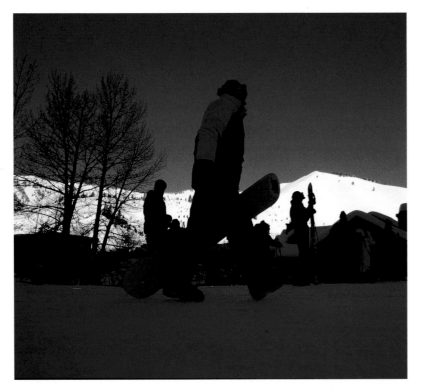

December
Warm Springs Lodge

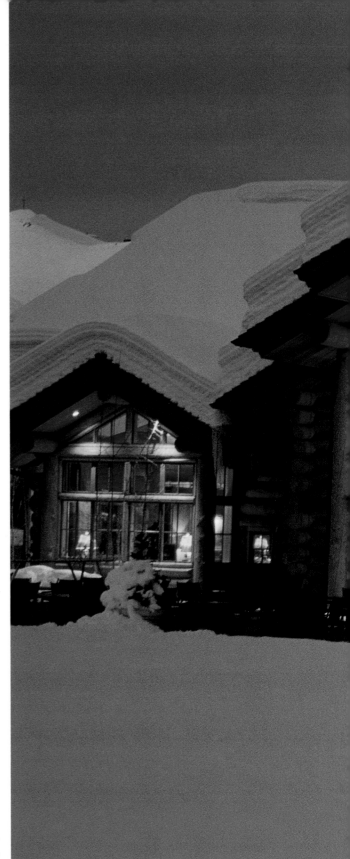

Evening
River Run Lodge

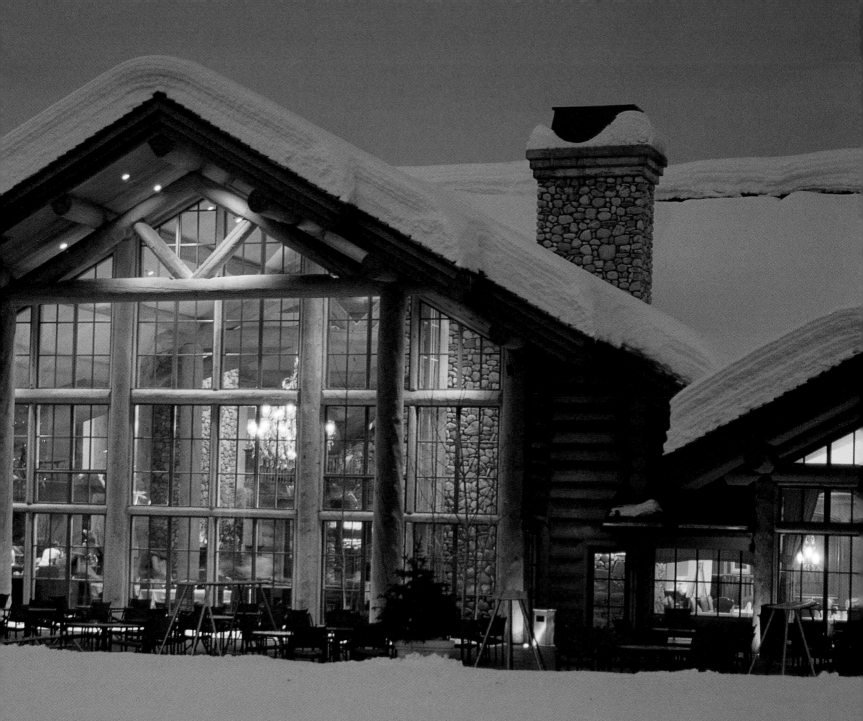

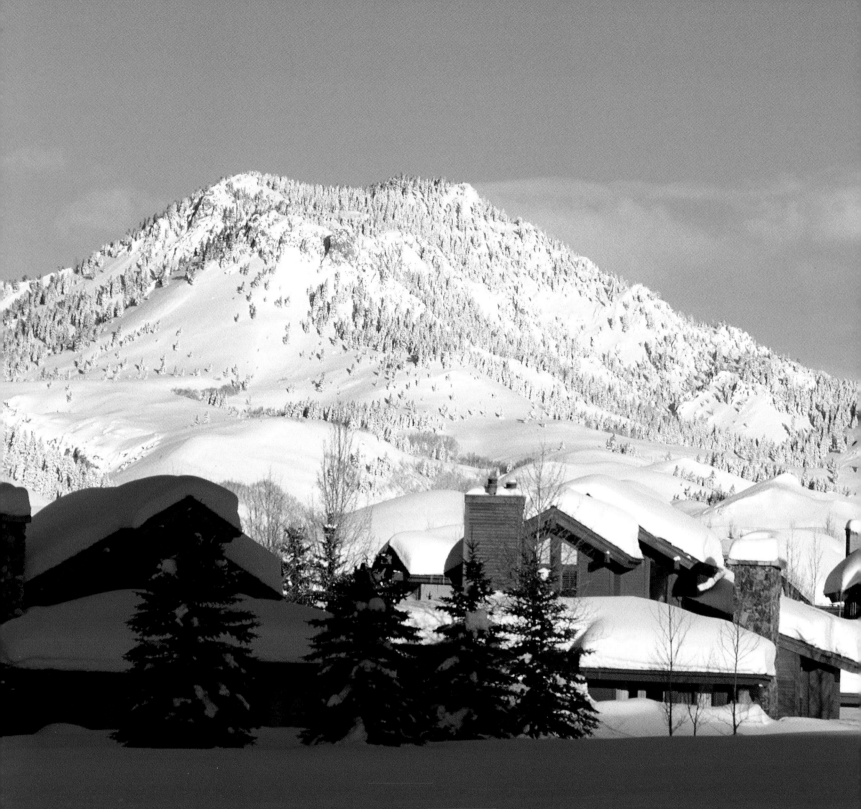

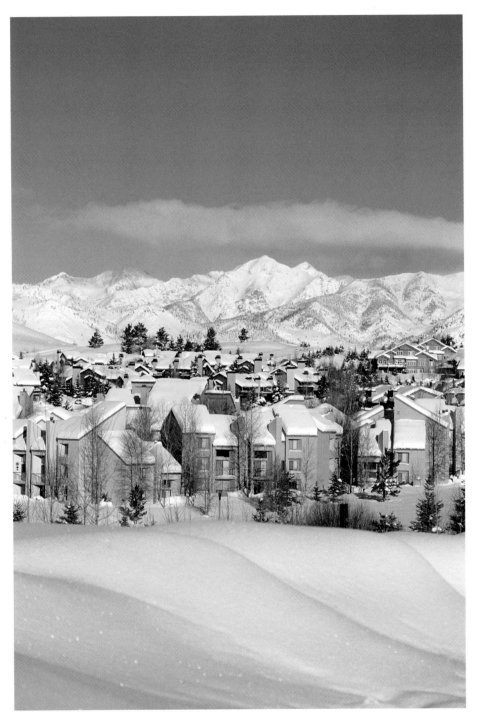

Elkhorn and the Boulder Mountains

Weyakkin and Griffin Butte

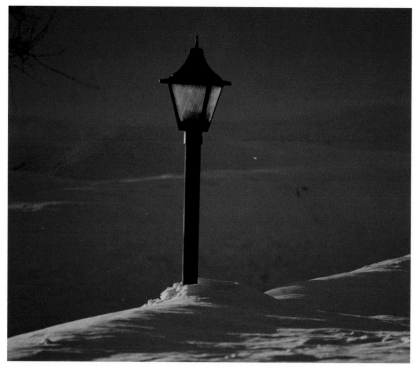

Lamppost
Sun Valley

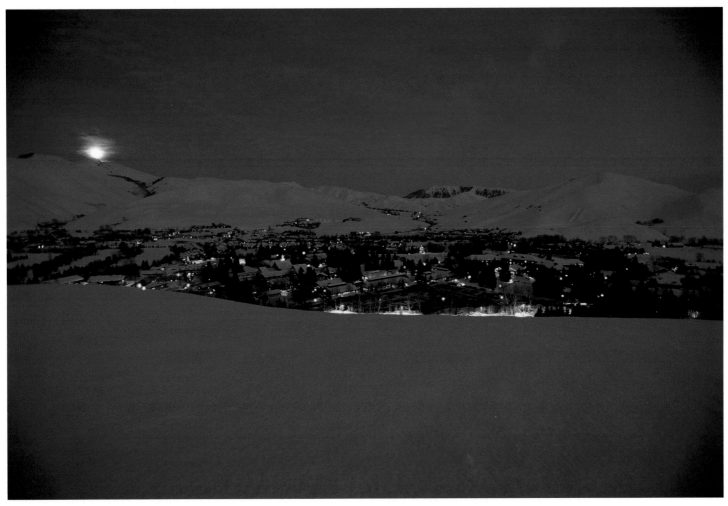

Full moon over Sun Valley

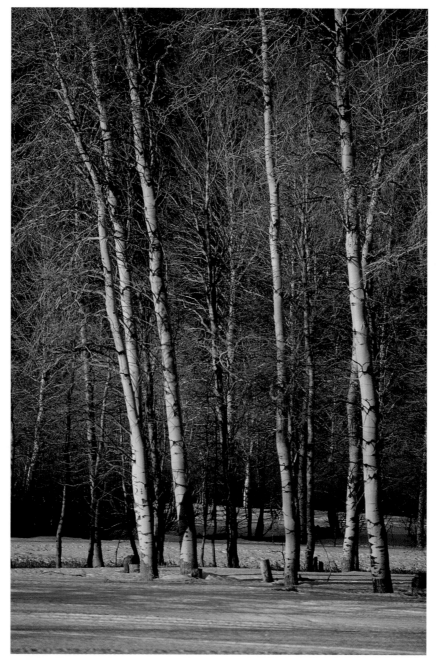

Golden aspens
Smoky Mountains

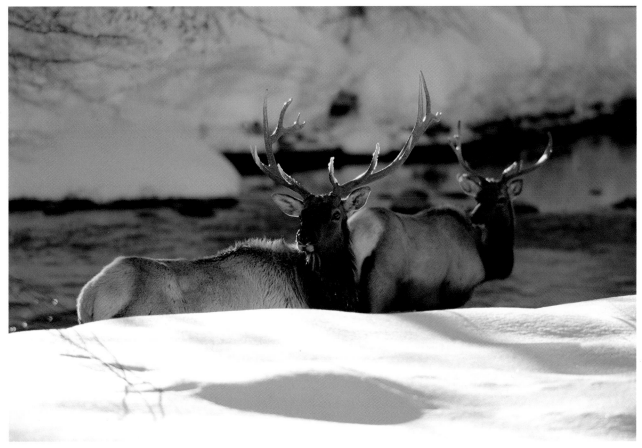

Elk
Big Wood River

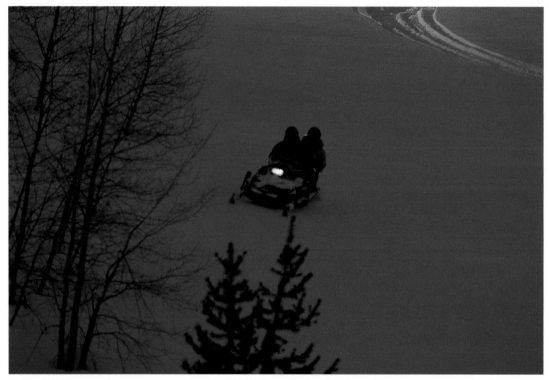

Snowmobiling
Boulder Mountains

Snowstorm
Boulder Mountains

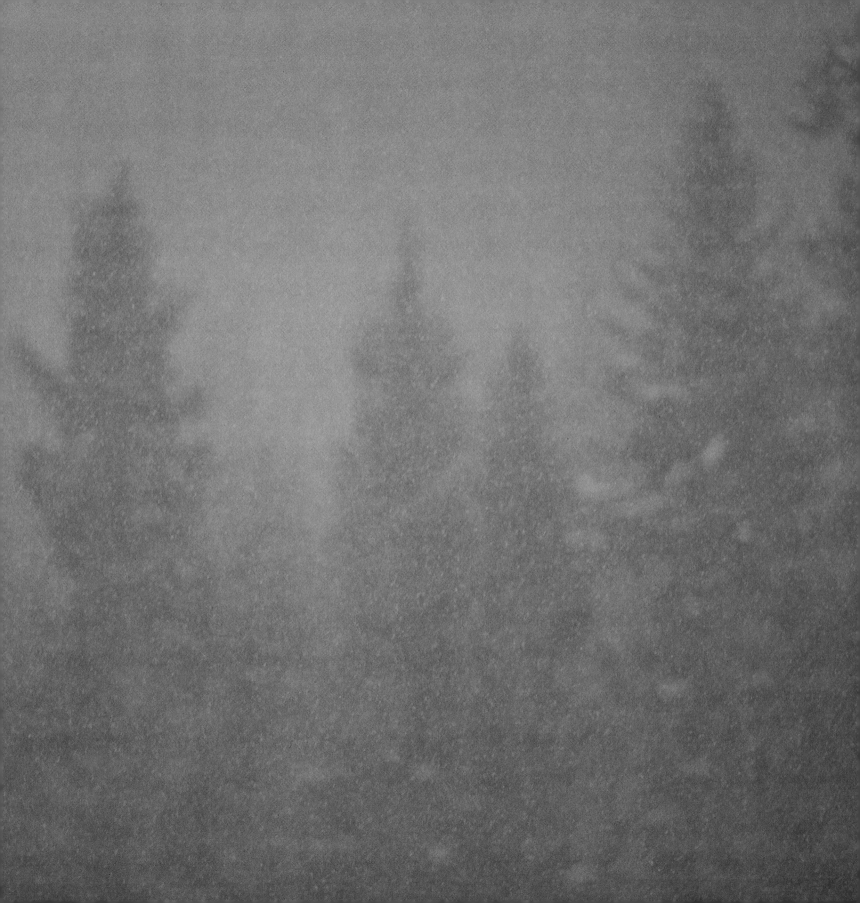

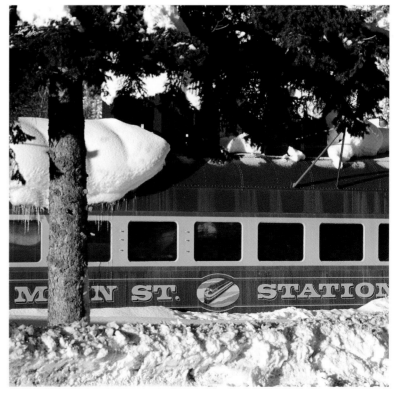

Popular Ketchum and Sun Valley spots

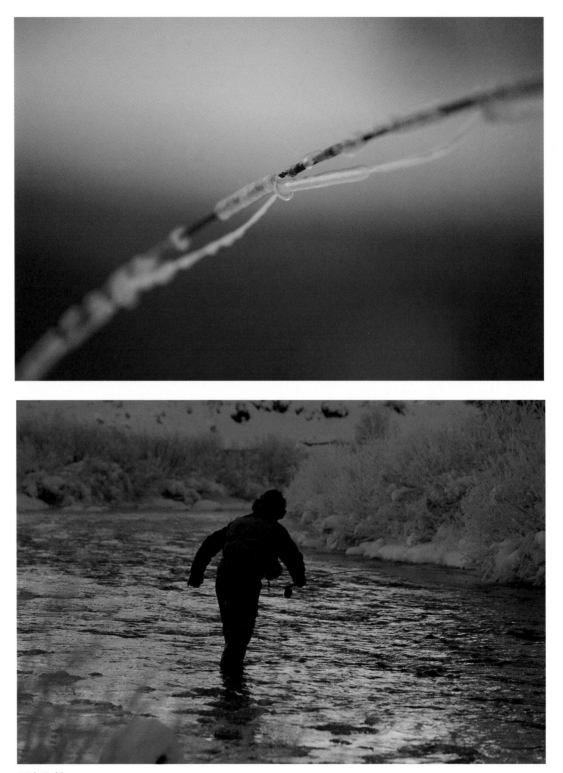

Dick Dahlgren
Big Wood River

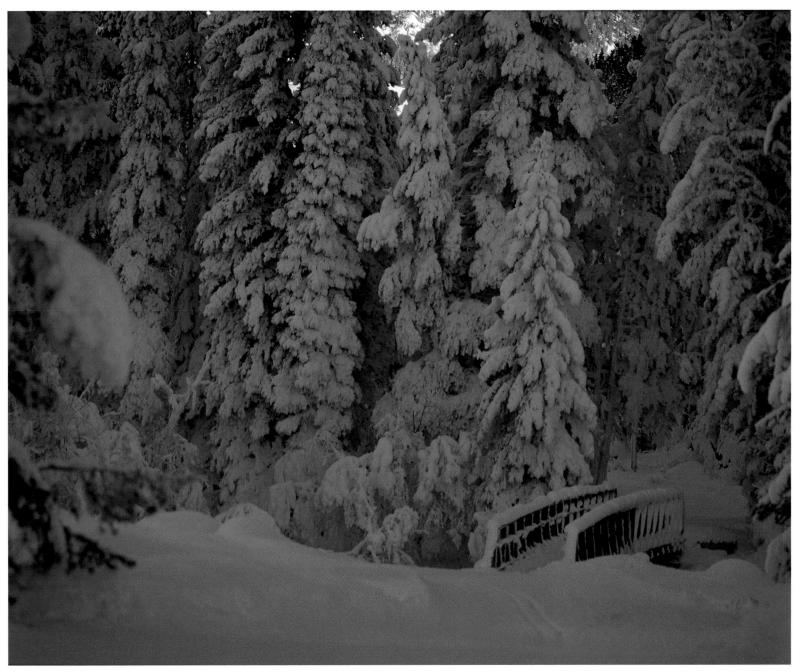

Murphy Bridge
Big Wood River

Kenton Carruth gets big air

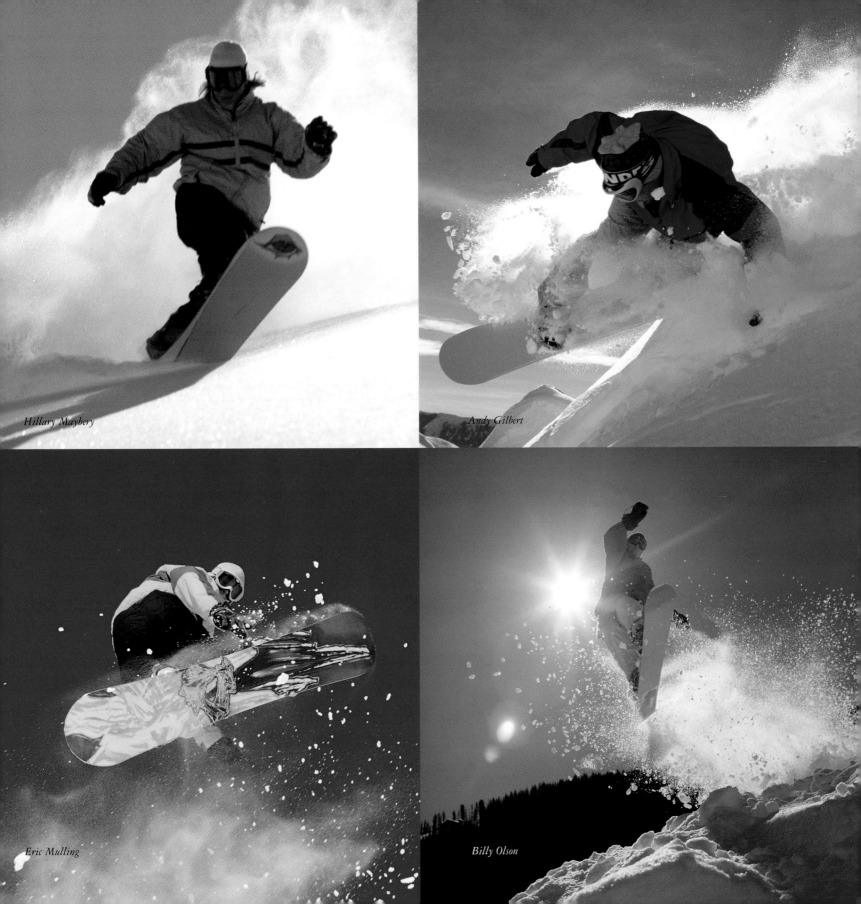

Hillary Maybery

Andy Gilbert

Eric Mulling

Billy Olson

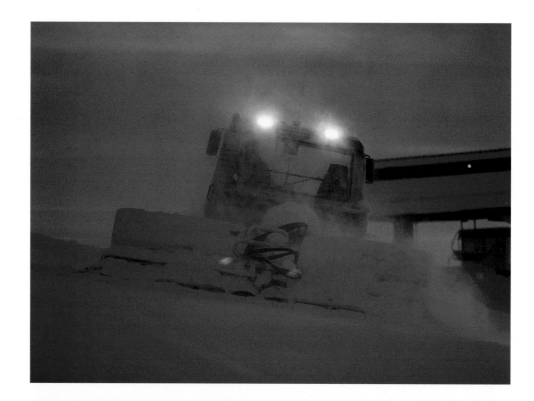

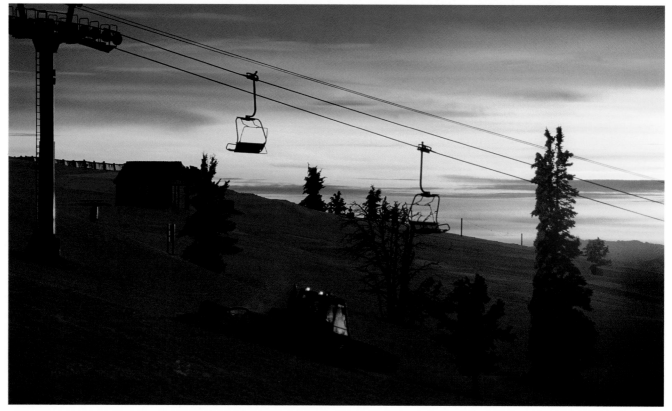

Snowcats
Top of Bald Mountain

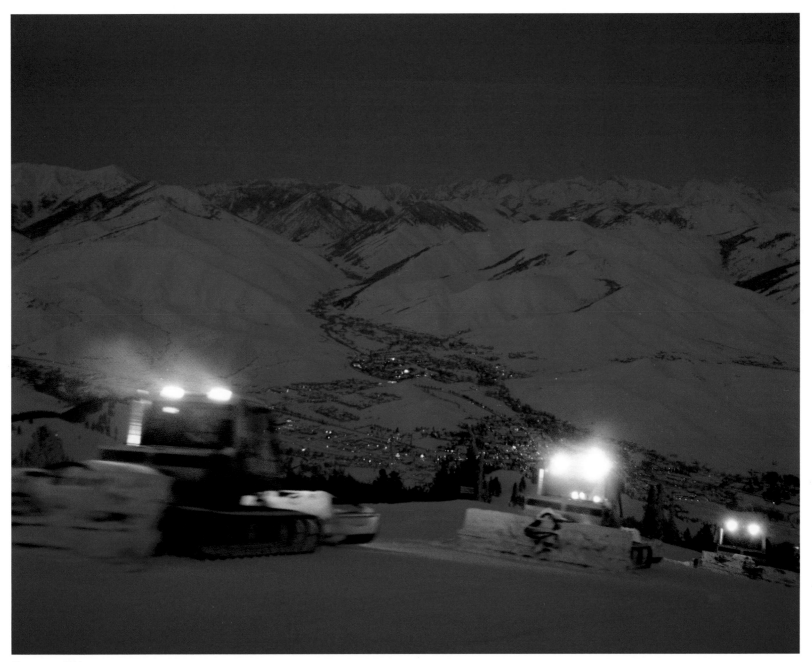

Snowcats on Ridge
Bald Mountain

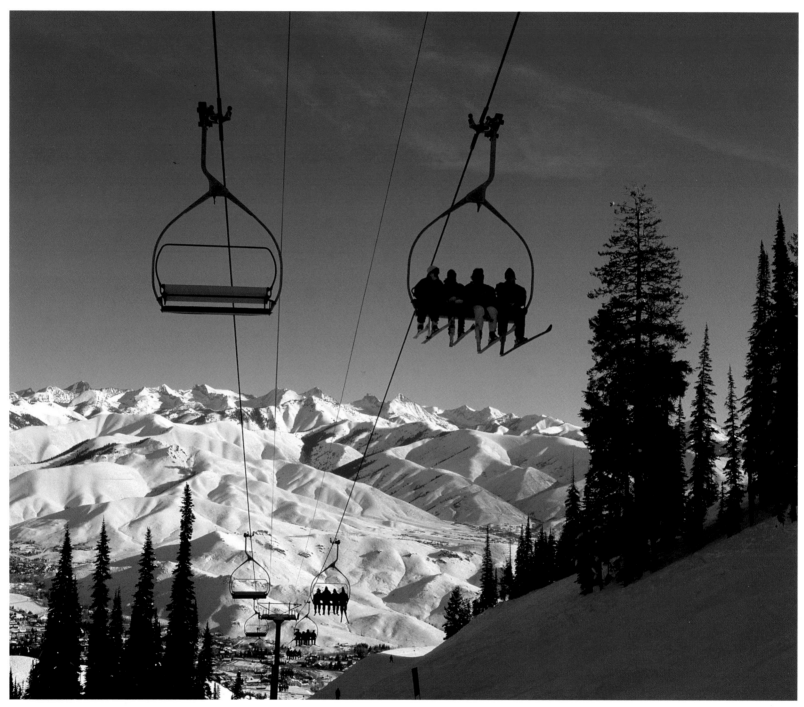

Lookout Express chair

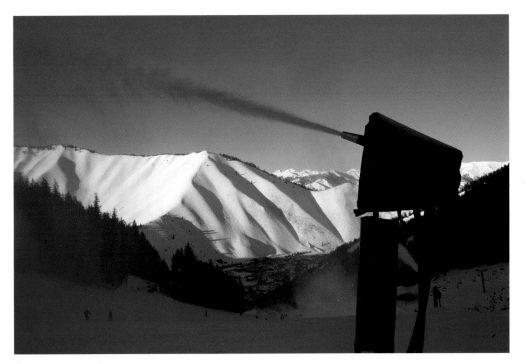

Snow gun
Bald Mountain

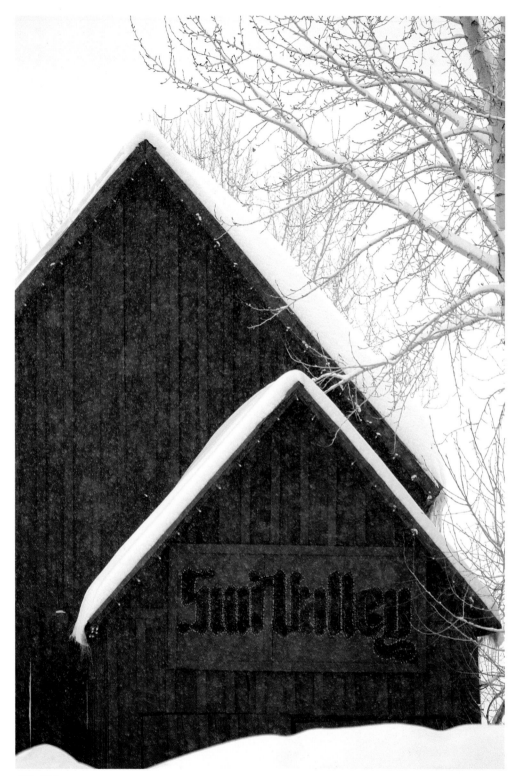

Old mill barn
Sun Valley Road

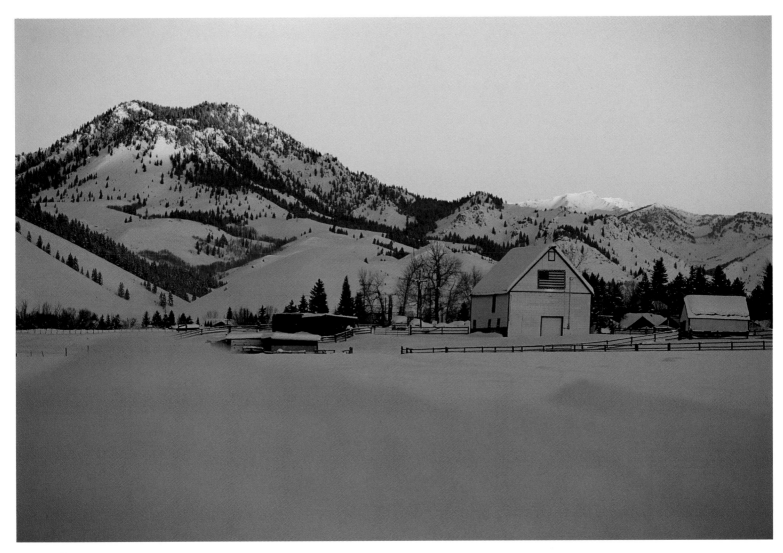

Sunrise, Christmas morning
Mike Turzian decorated the Reinheimer barn after 9/11

Pool at Sun Valley Inn

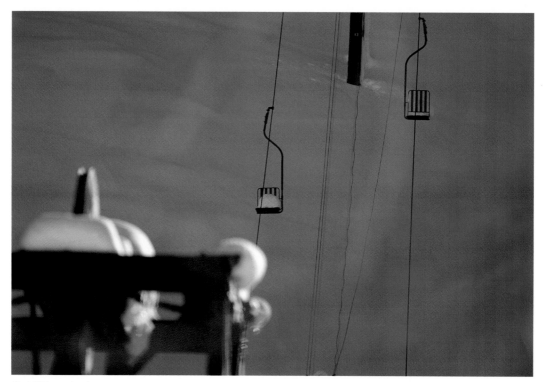

Ruud Mountain chair

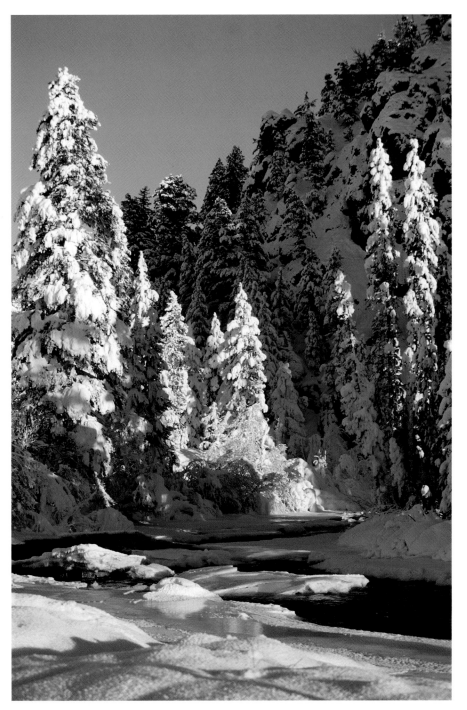

Murphy Bridge, January
Big Wood River

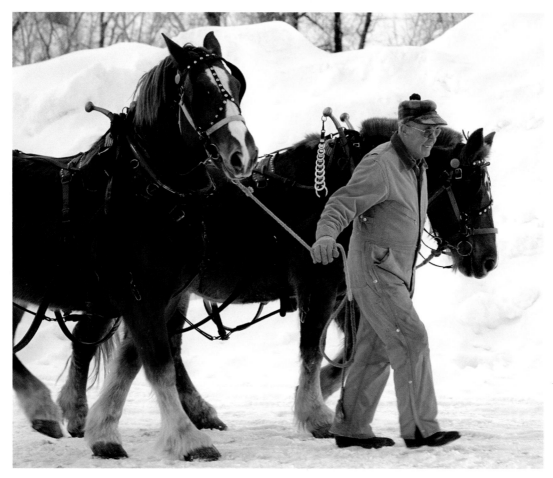

Harrold Dressol harnessing the horses for the Trail Creek sleigh ride

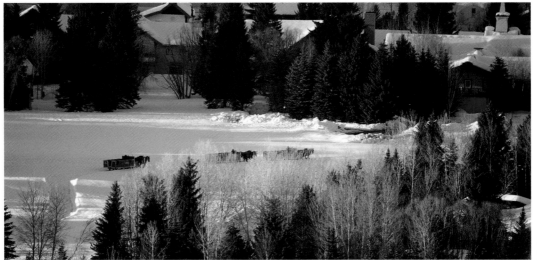

Sleigh ride
Trail Creek Cabin

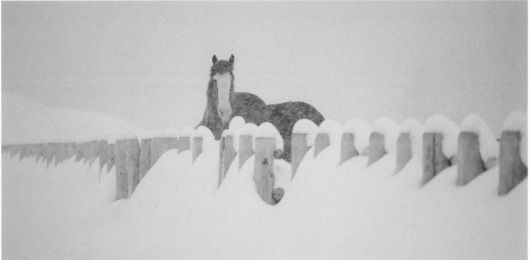

Sleigh horse in storm

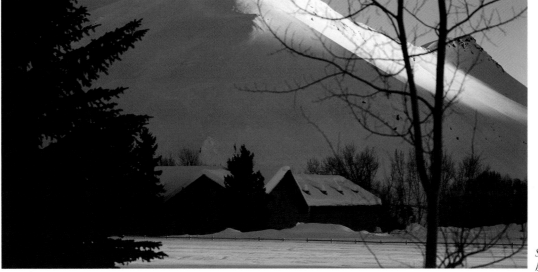

Sun Valley
horse barn

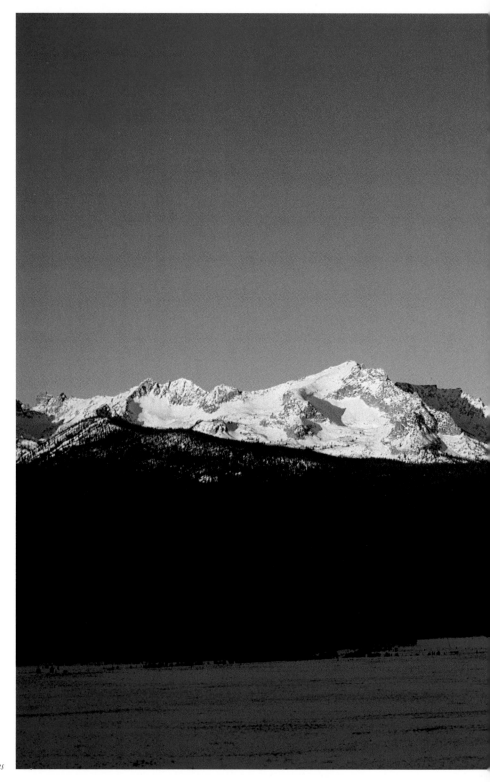

Moon over the Sawtooth Mountains

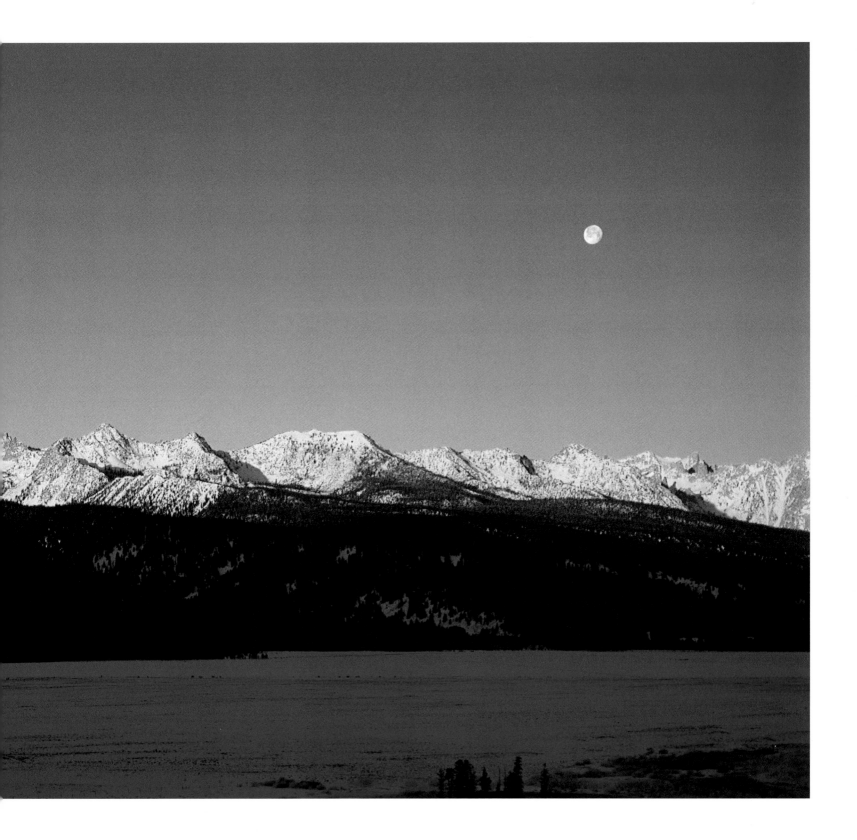

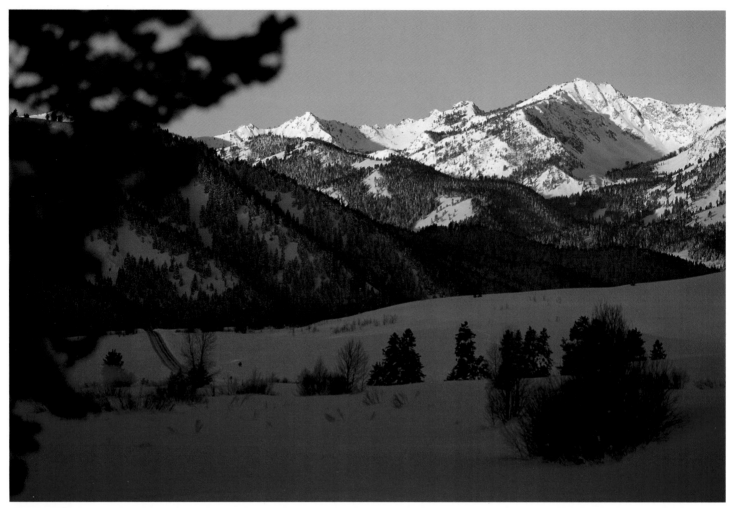

Phantom Hill
Highway 75 North

Fish Hook Creek
Sawtooth Mountains

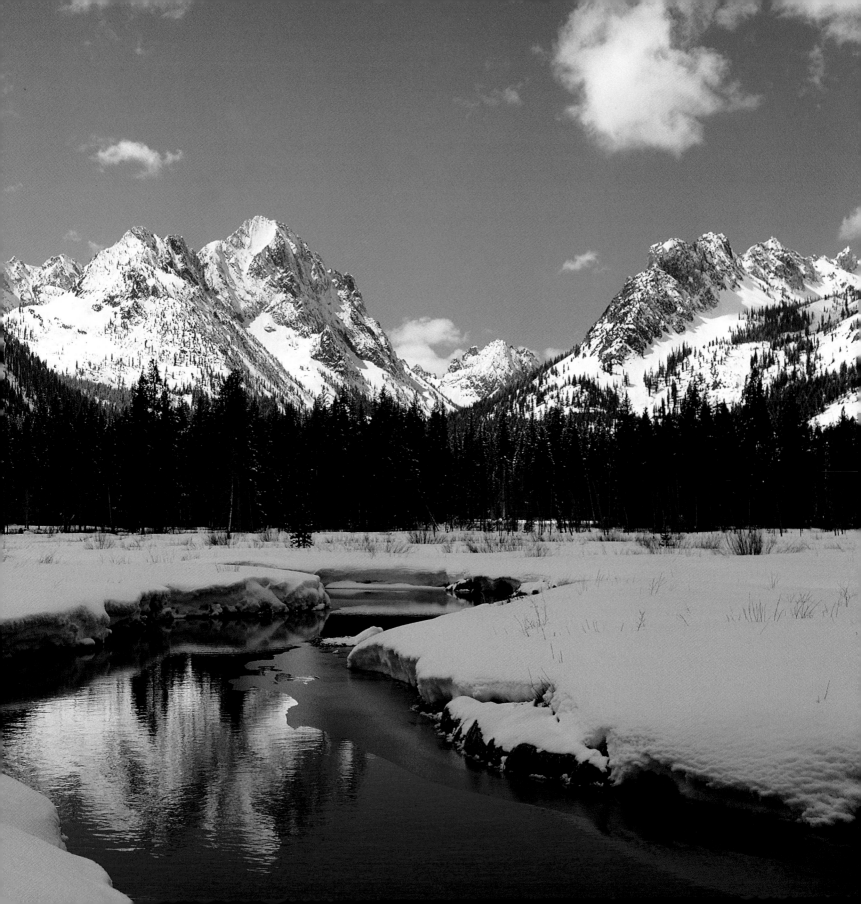

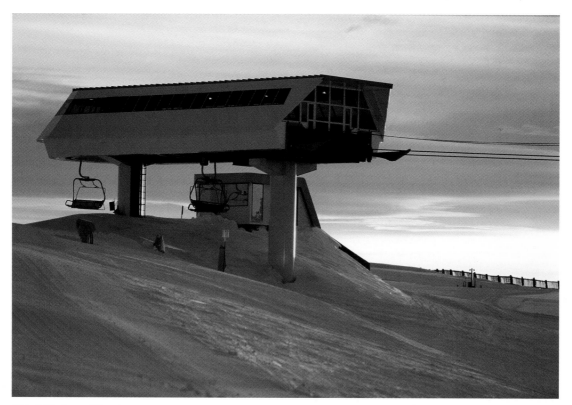

Top of Challenger lift
Bald Mountain

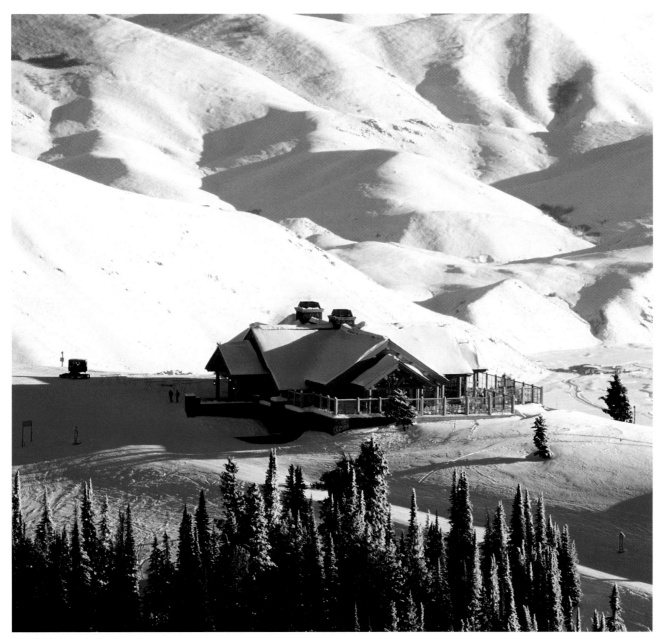

Seattle Ridge Lodge

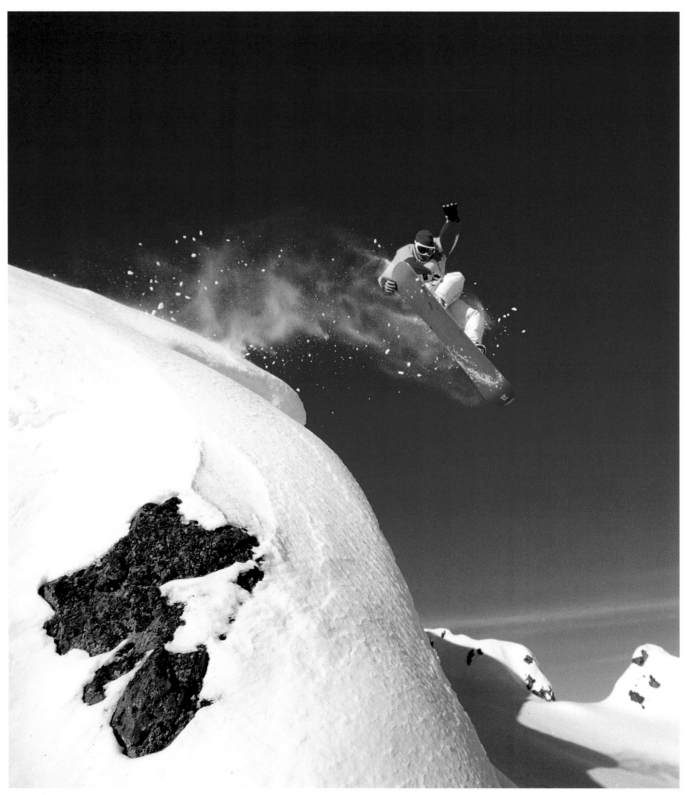

AJ Grabos
Top of Dollar Mountain

Shroder Baker

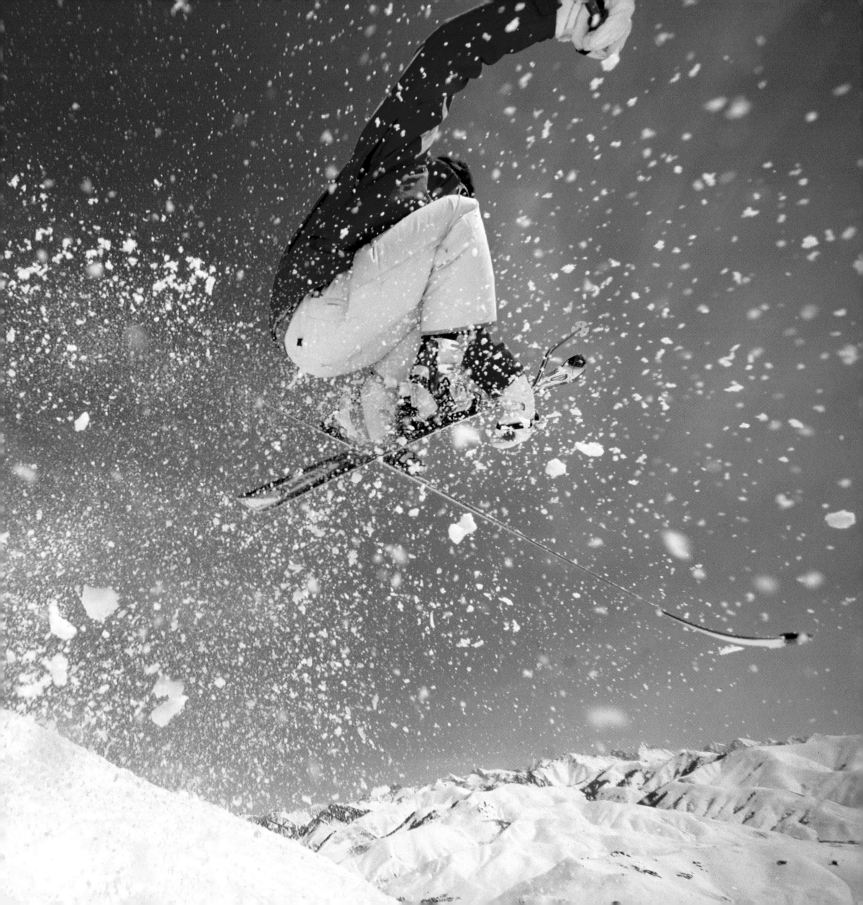

Spring
Summer

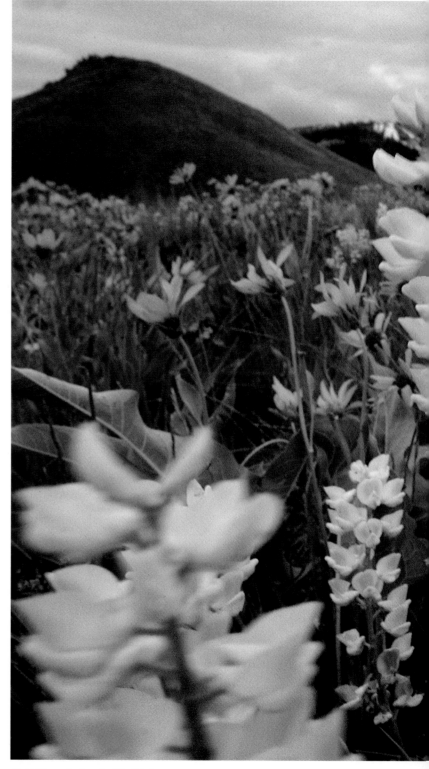

Bald Mountain from Saddle Road

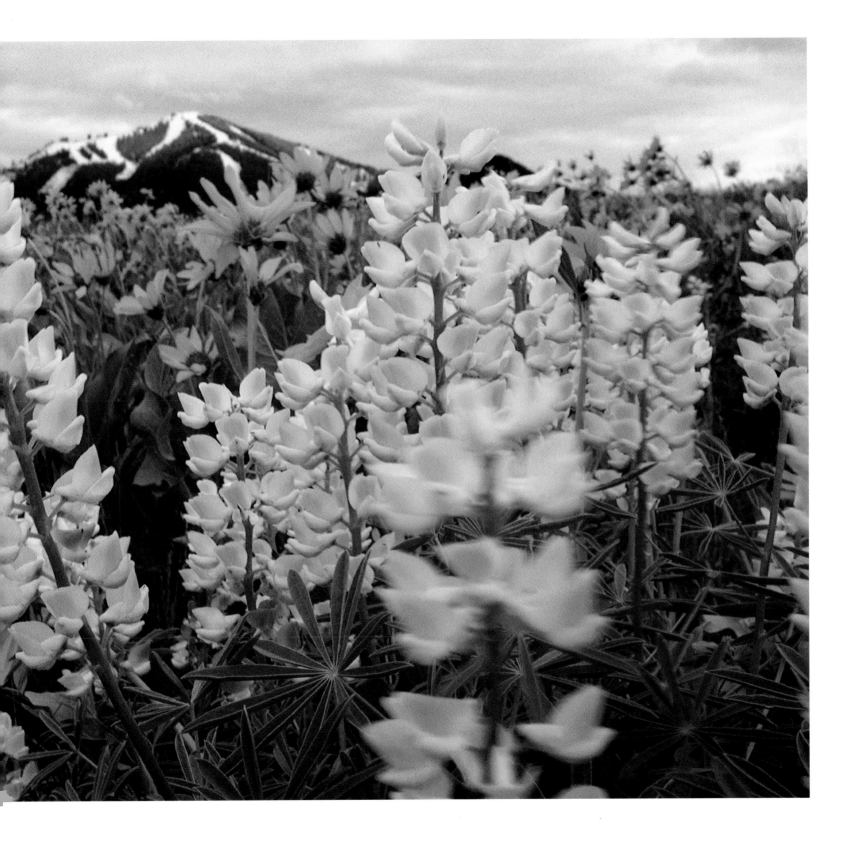

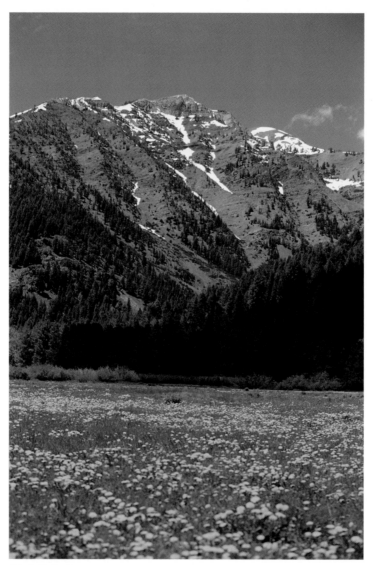

Big Fall Creek
Boulder Mountains

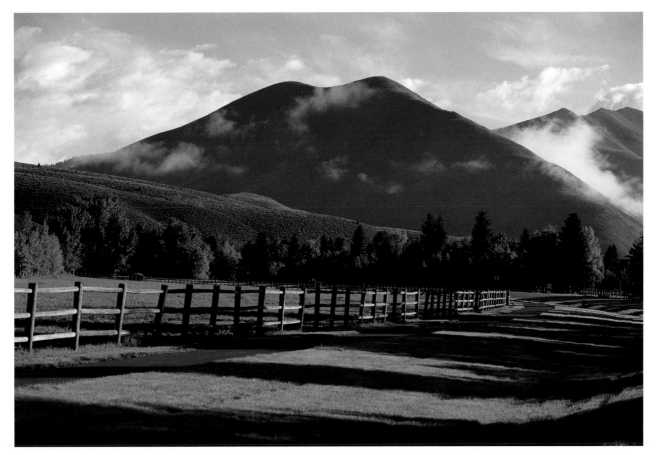

Sun Valley Road and the old horse pasture

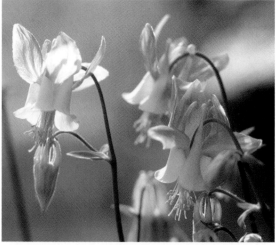

Columbine

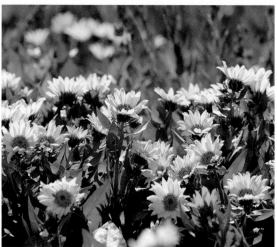

Arrowleaf balsamroot

Lupine

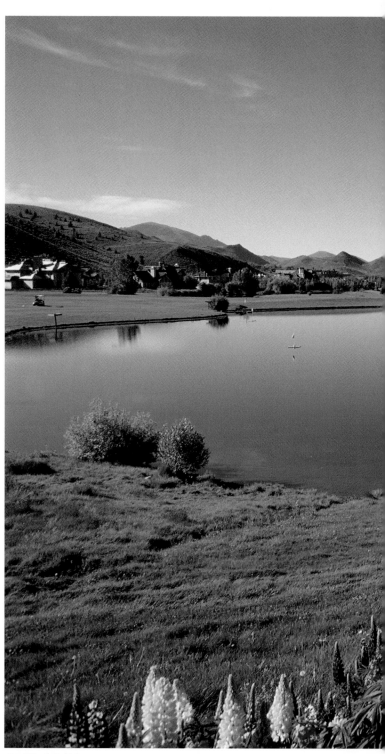

Big Wood Golf Course

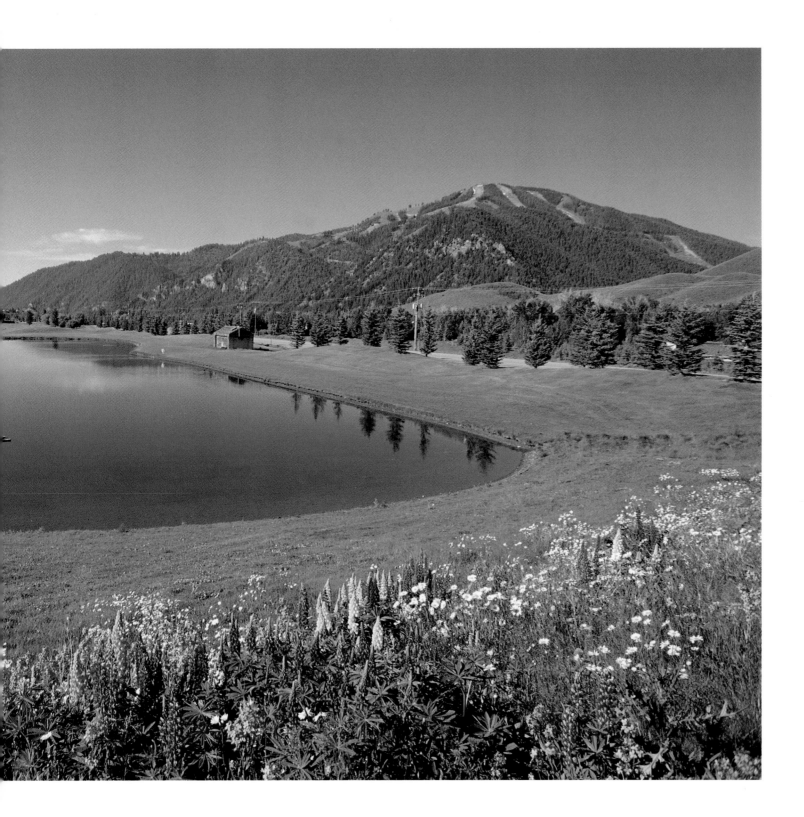

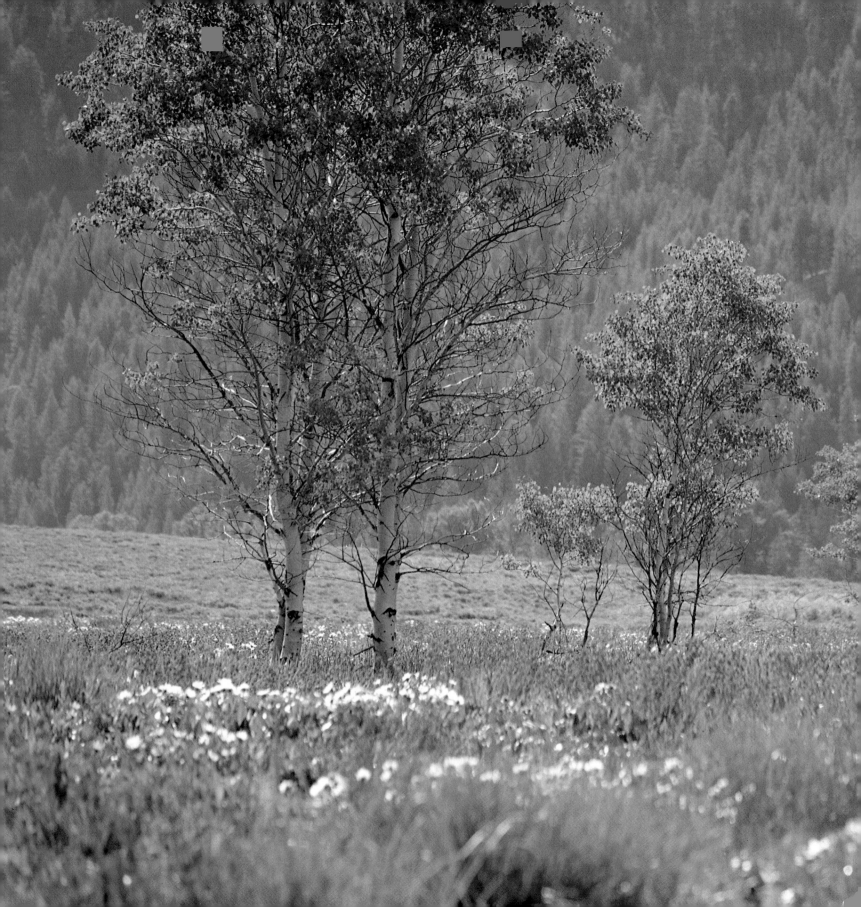

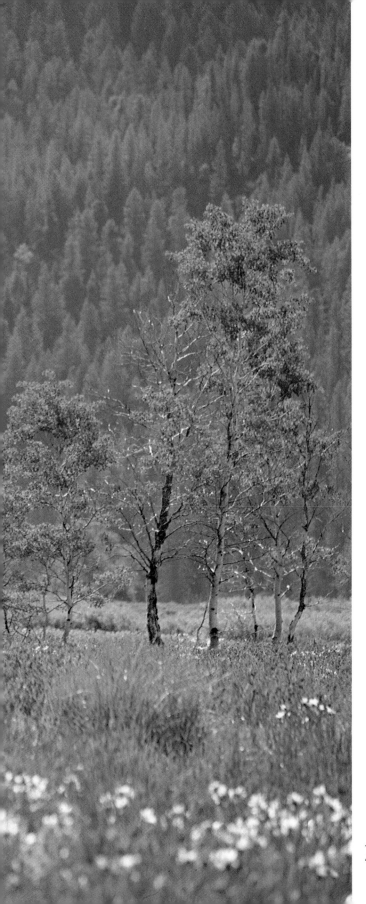

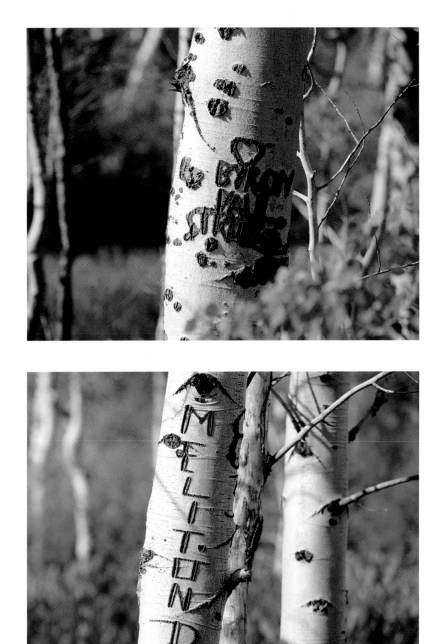

Basque writing on aspen trees

Aspen trees
Smoky Mountains

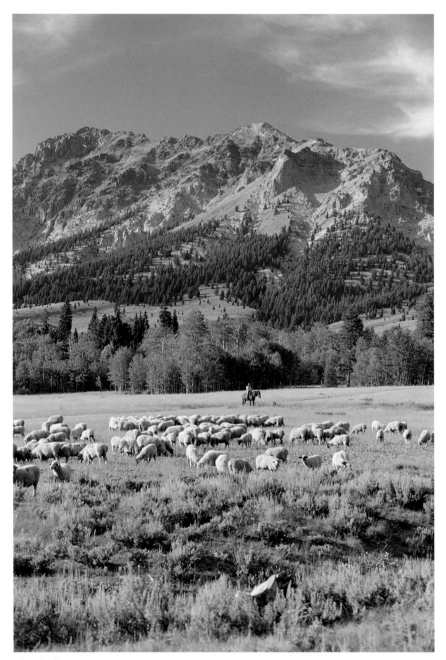

Sheep herder
Boulder Mountains

Sheep
Sawtooth Valley

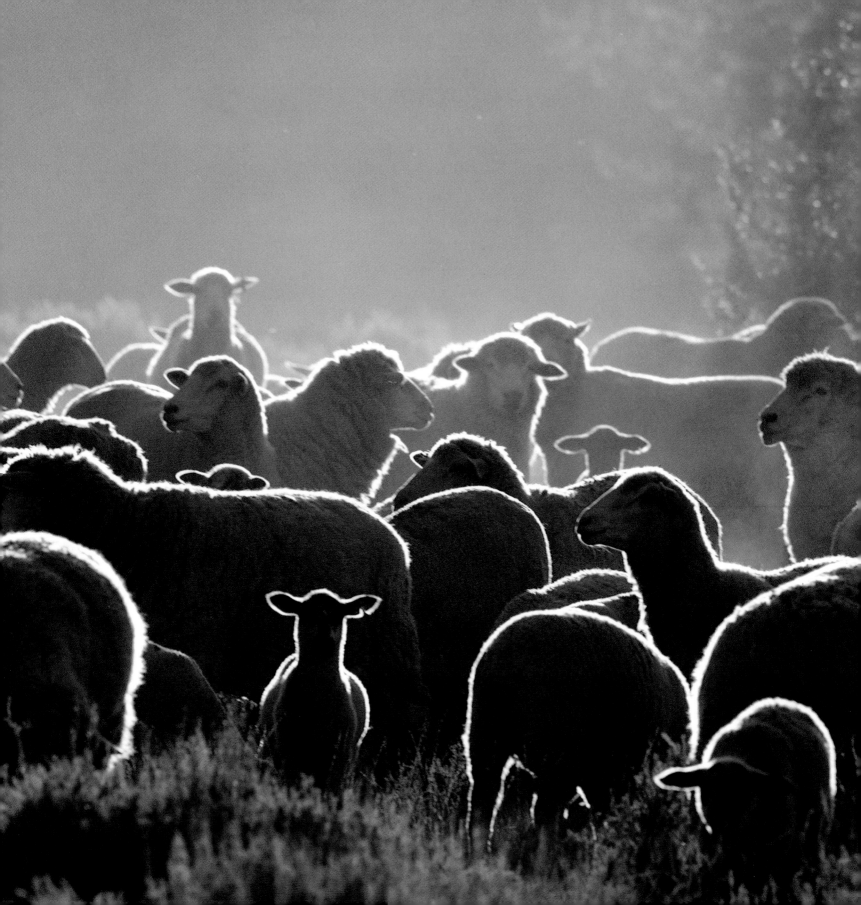

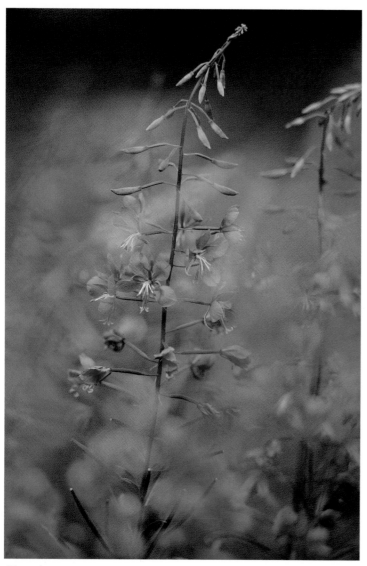

Fireweed

Zach Crist and Monica Chrestenson trail running
Pioneer Mountains, Copper Basin

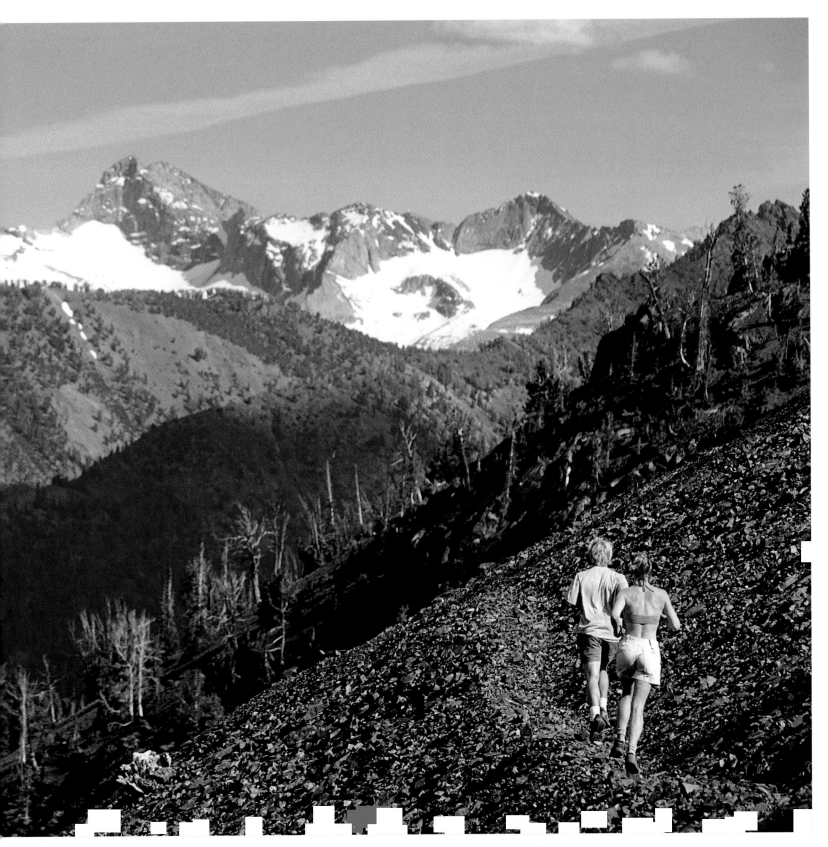

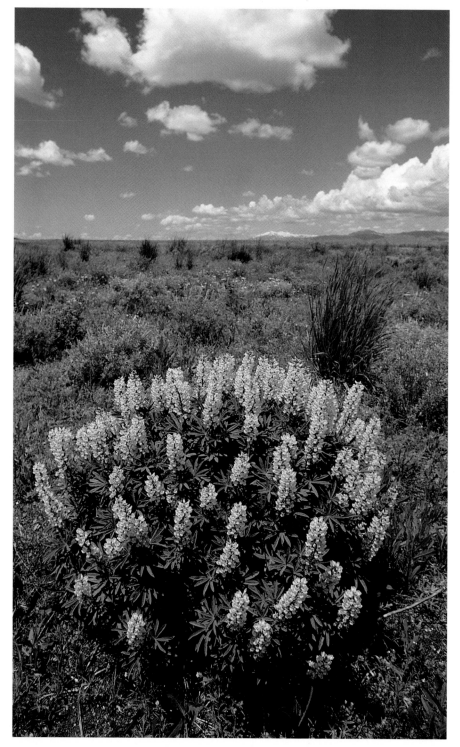

Lupine
Camas Prairie

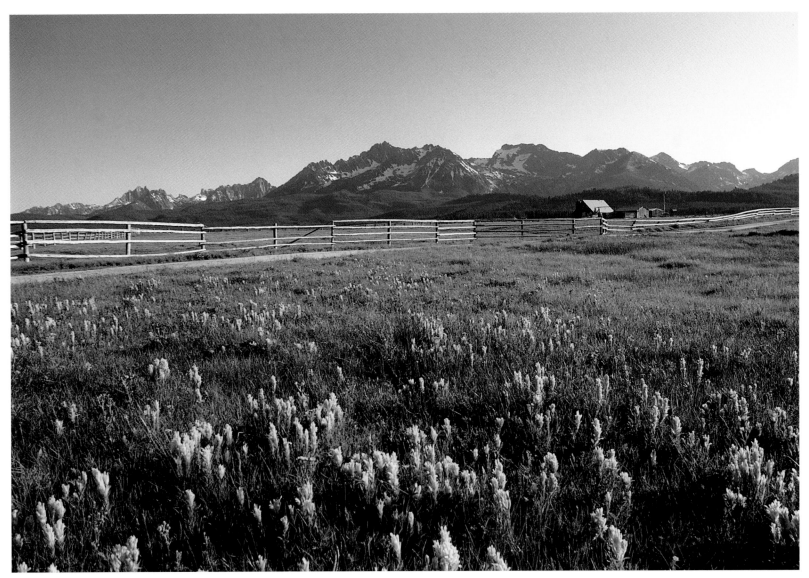

Sulfur paintbrush
Peva Ranch, Sawtooth Valley

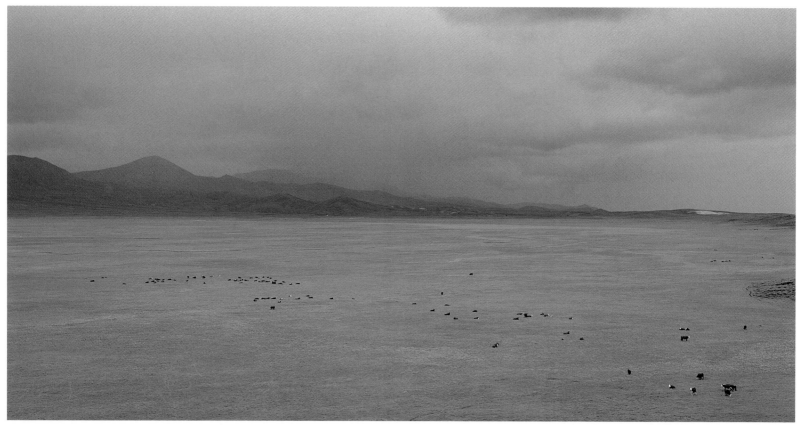

Spring storm
Cattle on the Camas Prairie

Arrowleaf balsamroot
Boulder Mountains

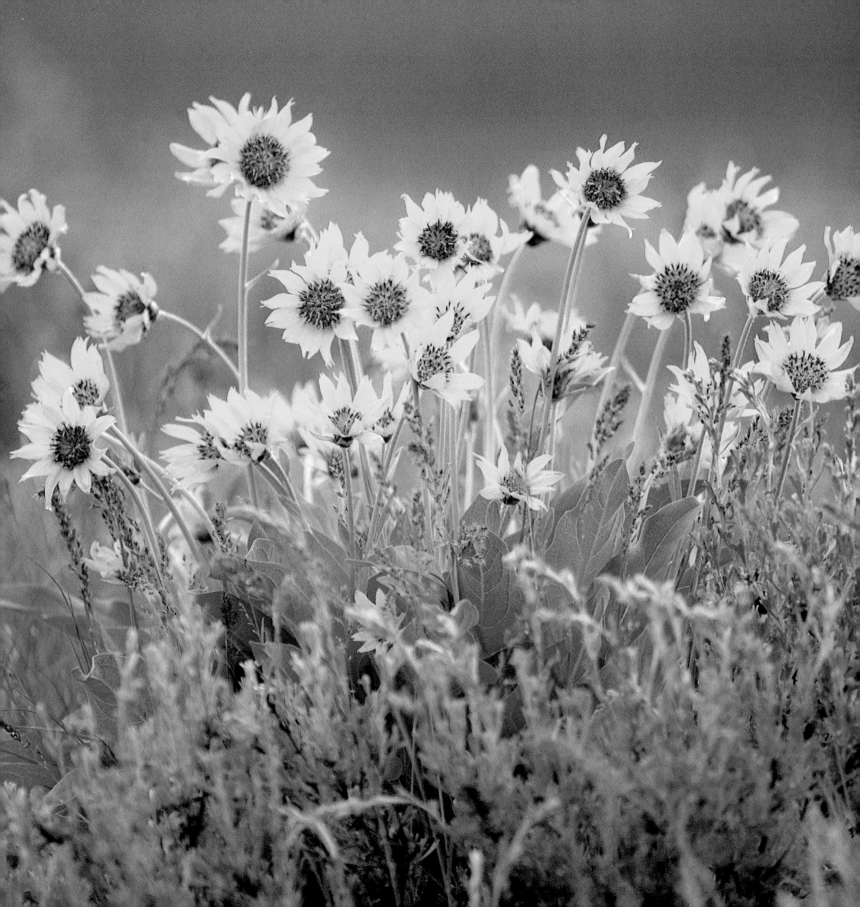

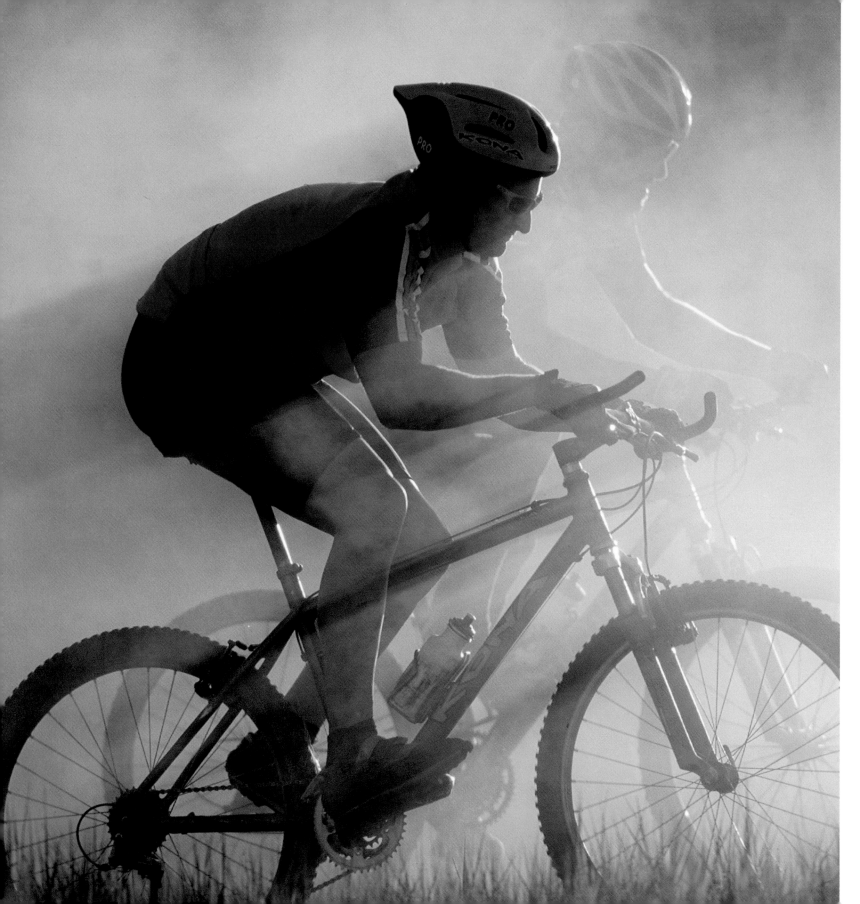

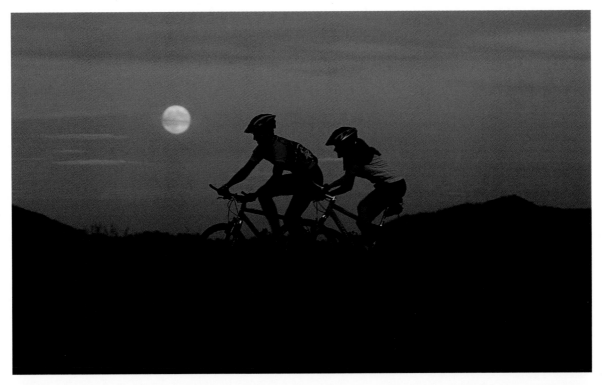

Liv and Tor Jensen

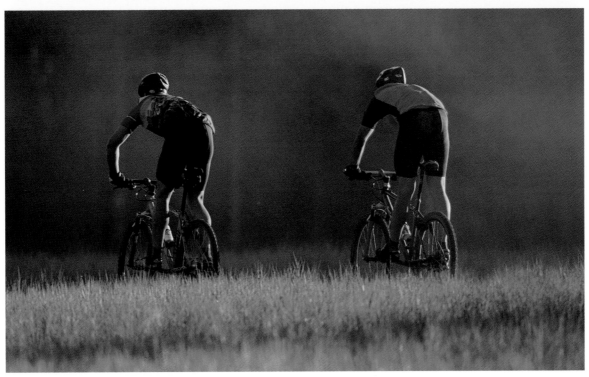

*Dave Golden and
Billy Olson*

*Dave Golden and Billy Olson
Boulder Mountains*

75

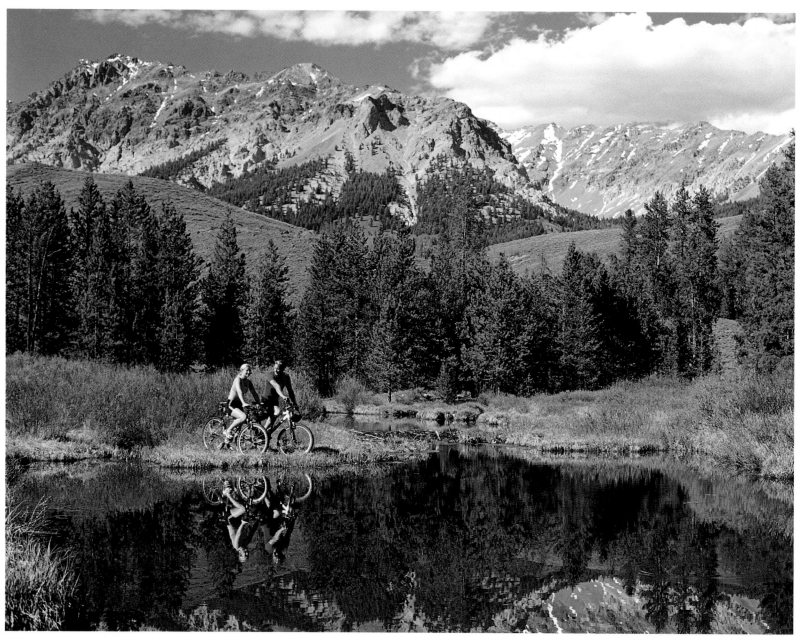

Stefan Leonhardt and Yvonne Hintzl
Boulder Mountains, beaver ponds

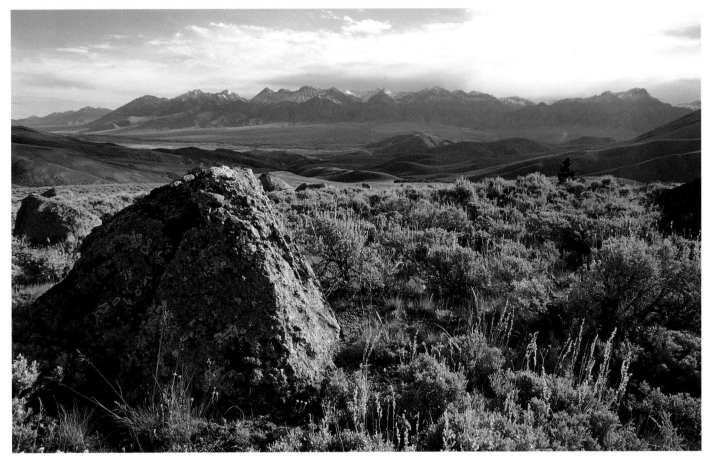

Clearing spring storm
Lost River Range, Mackay

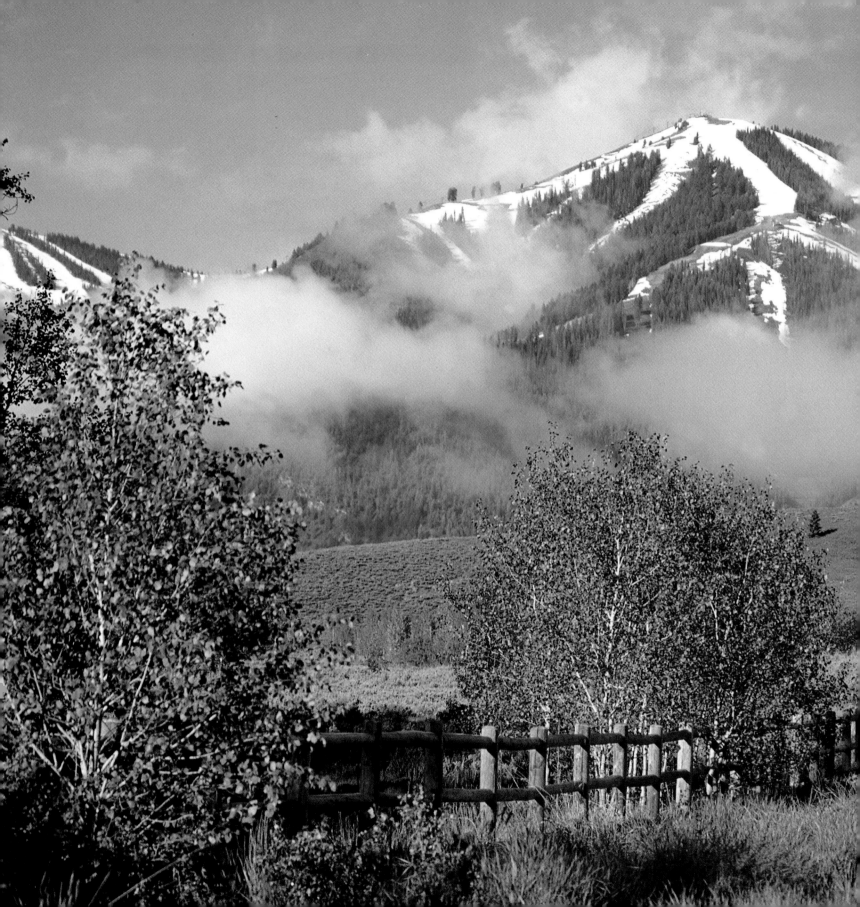

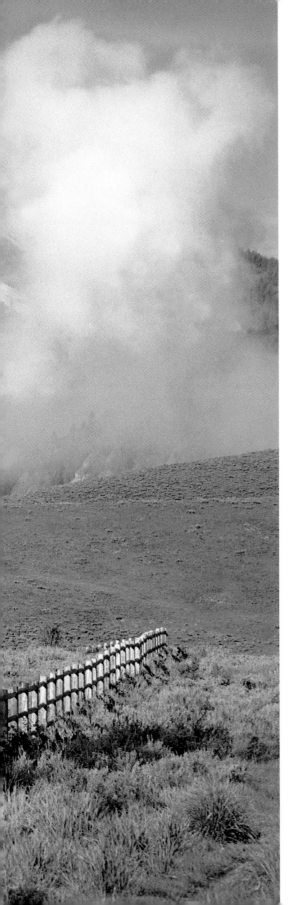

Rental bikes
Sun Valley

The Ram Bar
Sun Valley

Rising mist
Bald Mountain from Trail Creek Road

79

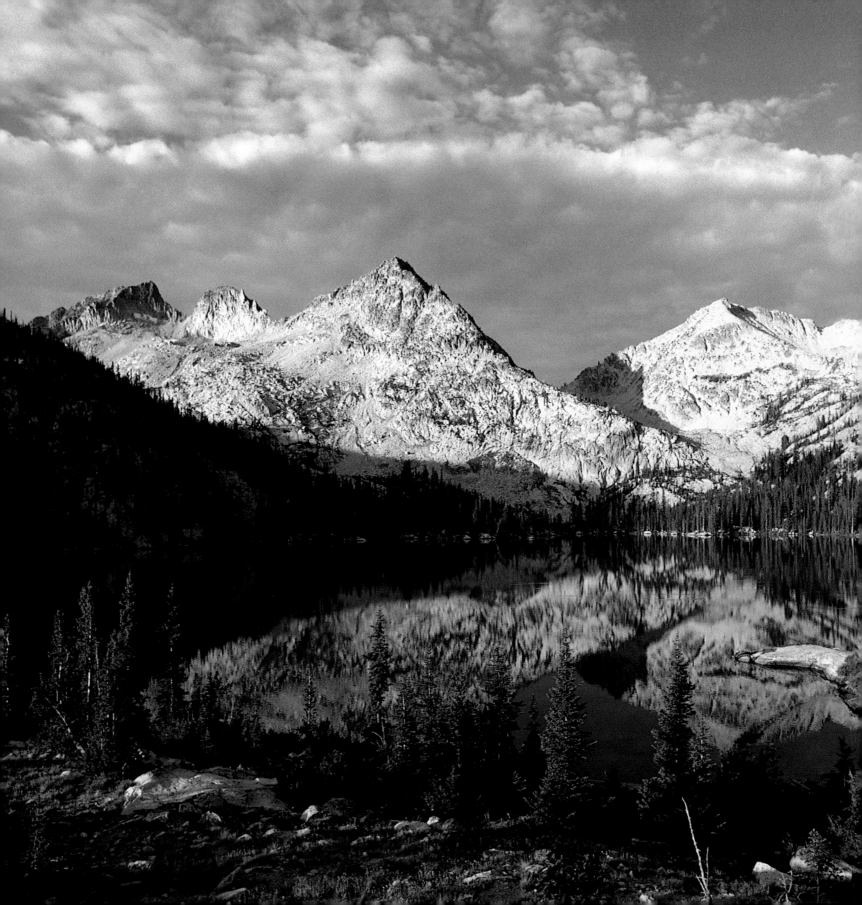

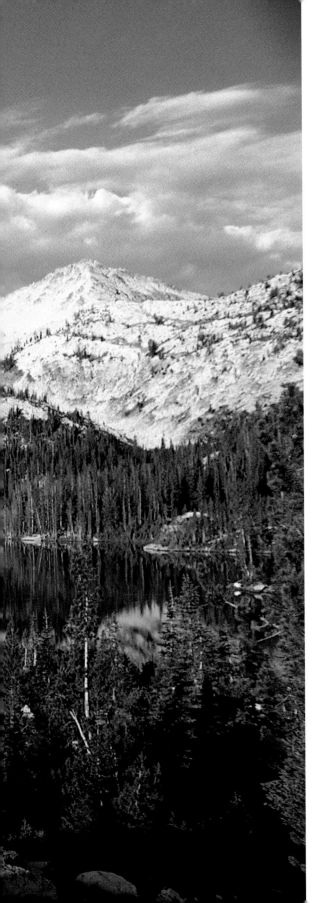

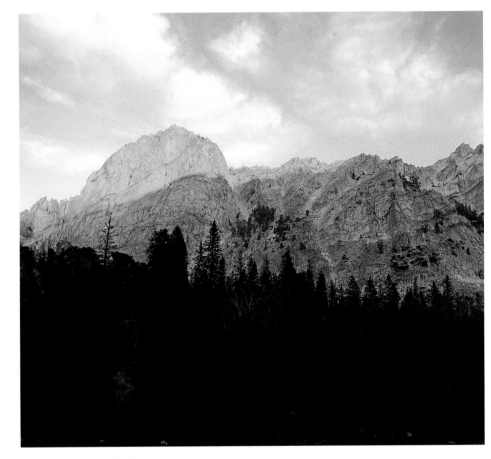

Sunset above Toxaway Lake
Sawtooth Mountains

Sunrise on Toxaway Lake
Sawtooth Mountains

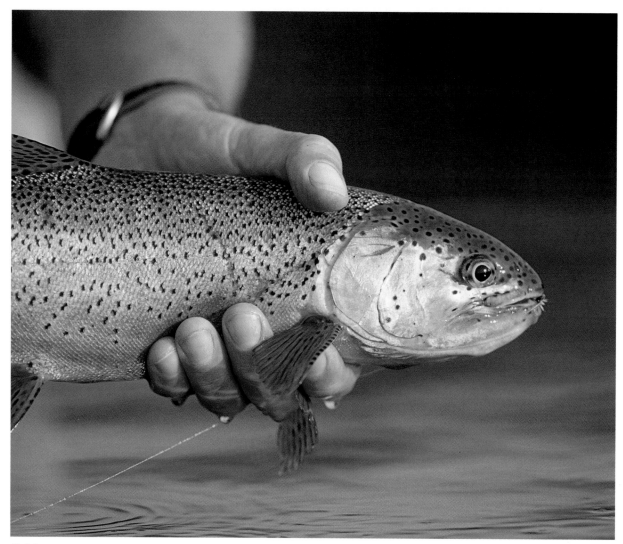

Rainbow trout
Mackay

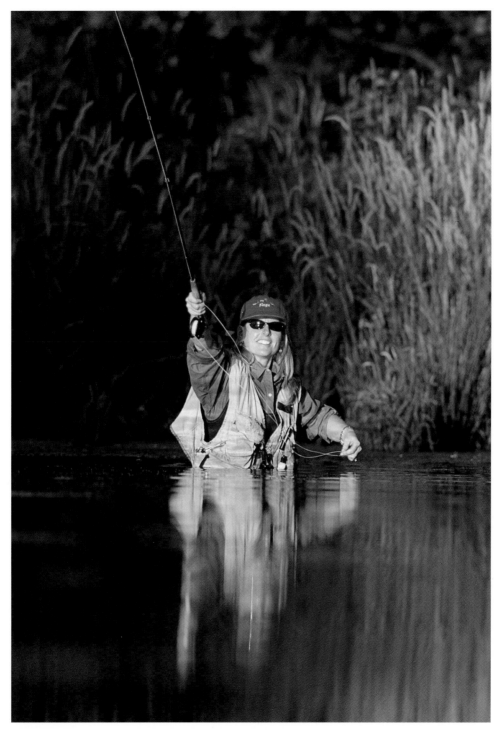

Jennifer Diehl
Silver Creek

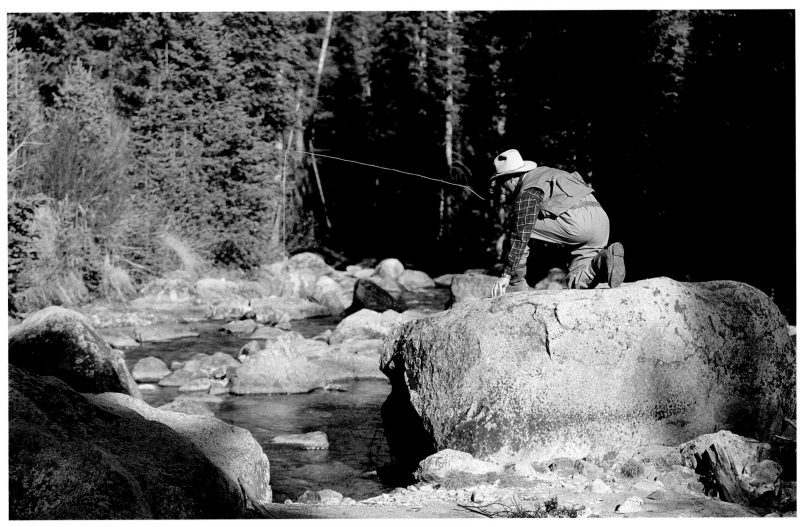

Chris Holley sneaks up on a pool
Wild Horse Creek, Copper Basin

Big Wood River

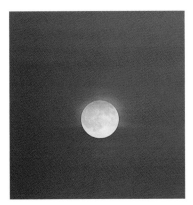

Mackay

Silver Creek

Big Lost River

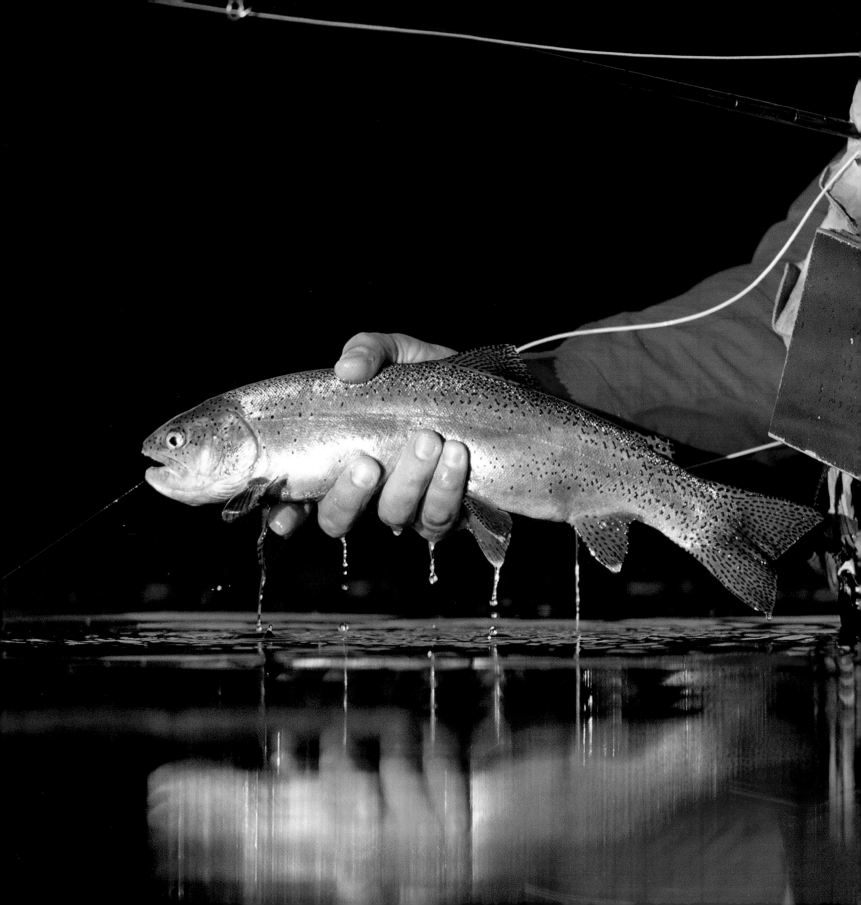

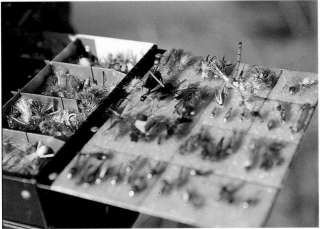

Fly box

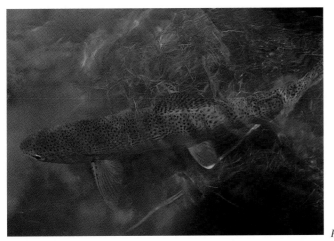

Rainbow

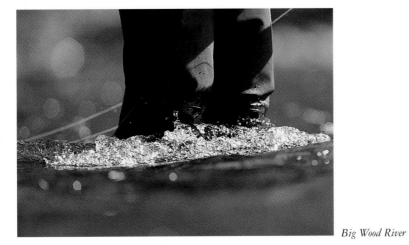

Big Wood River

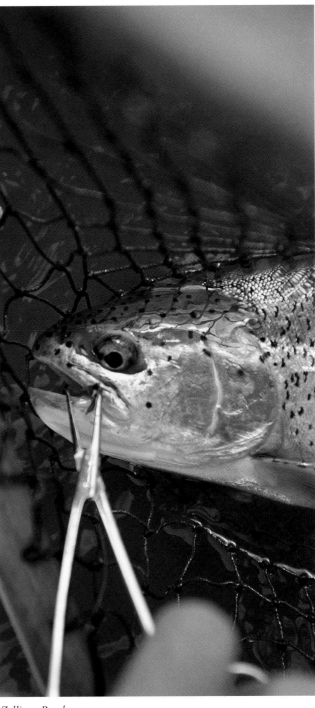

Zollinger Ranch

John Kendall
Silver Creek

87

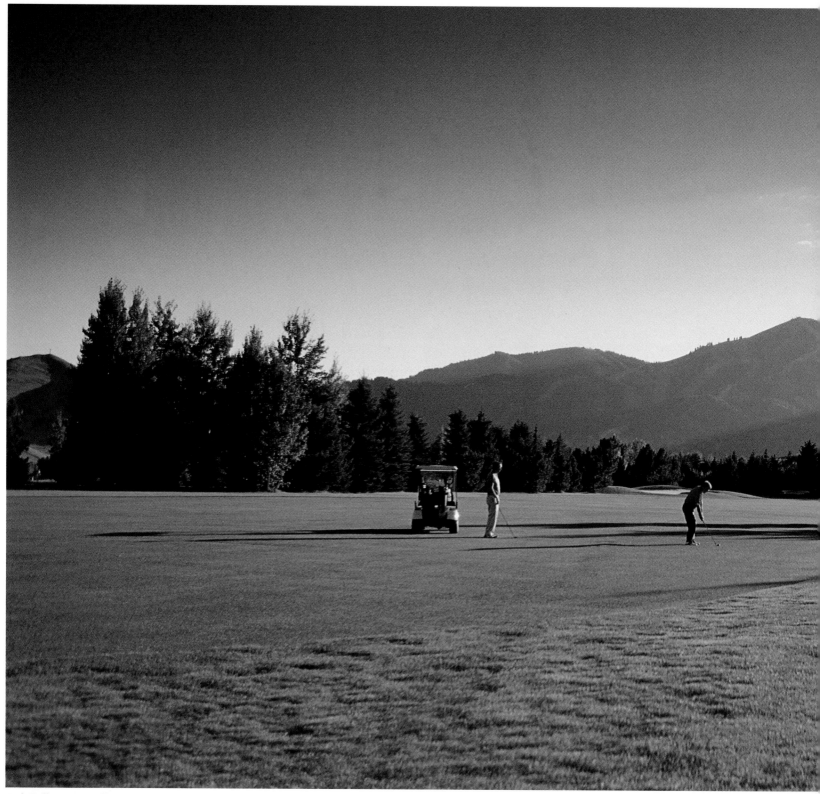

Jack Hoffman, Ken Fuller, and Gene Holman
Sun Valley

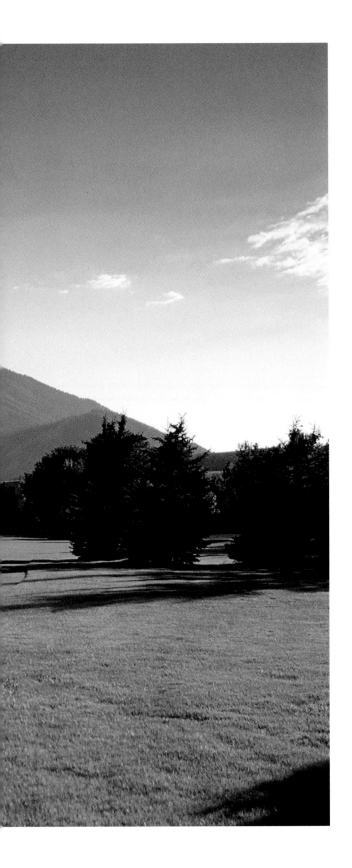

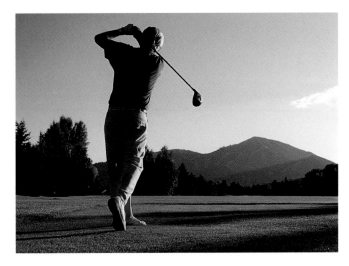

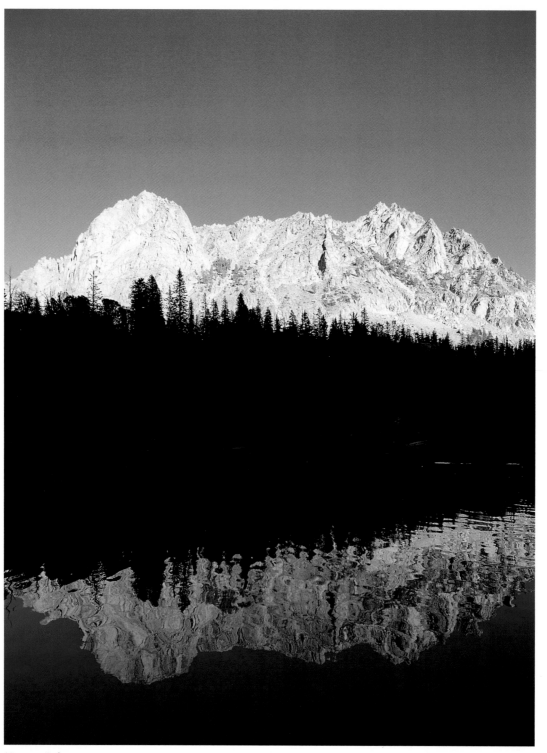

Toxaway Lake
Sawtooth Mountains

Castle Peak
White Cloud Mountains

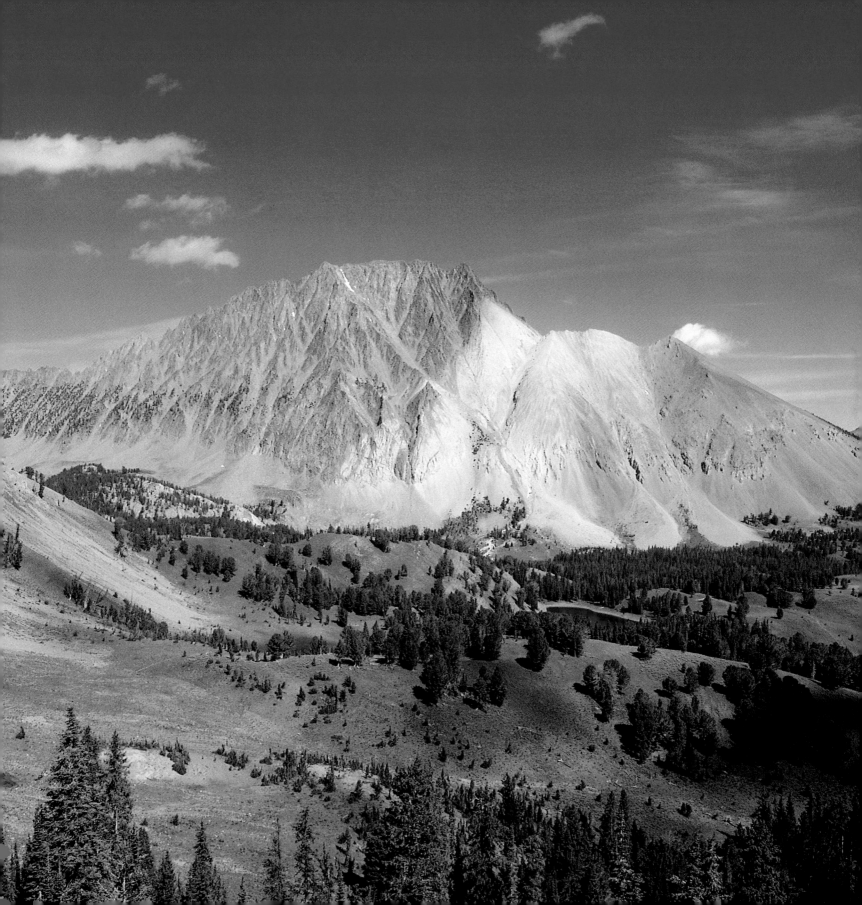

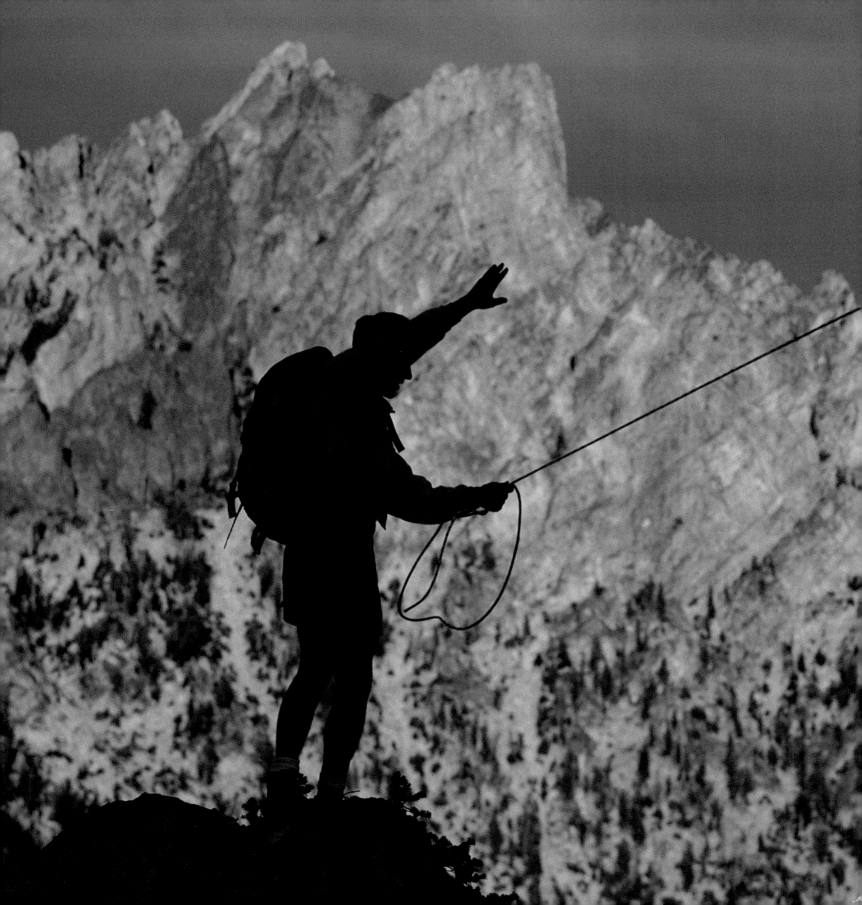

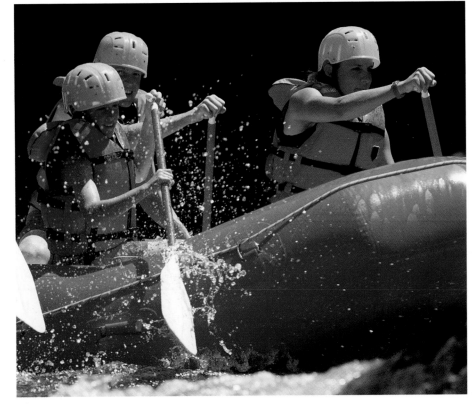

Payette River

Mountain climbing
Boulder Mountains

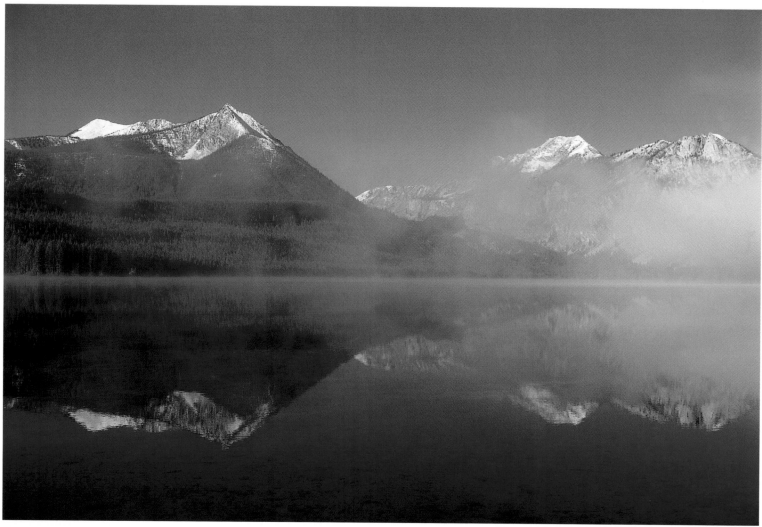

Morning mist on Pettit Lake
Sawtooth Mountains

Redfish Lake
Sawtooth Mountains

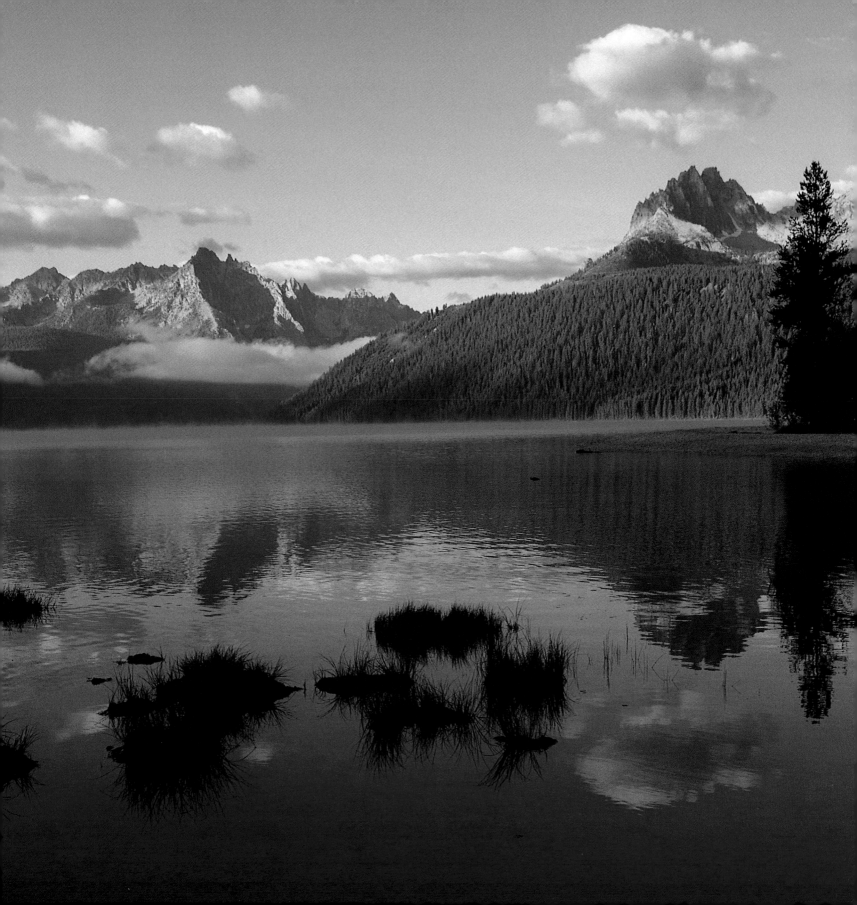

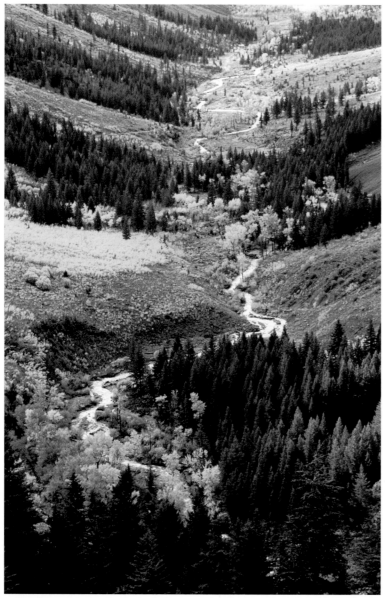

Trail Creek

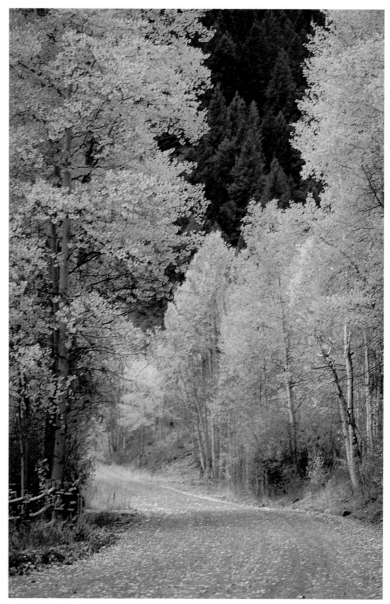

Warm Springs Road

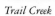

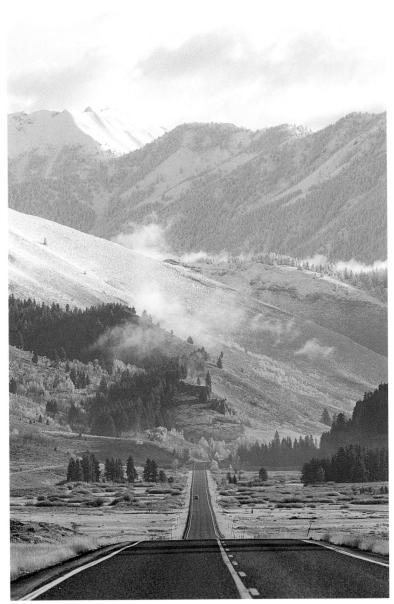

Phantom Hill
Highway 75 North

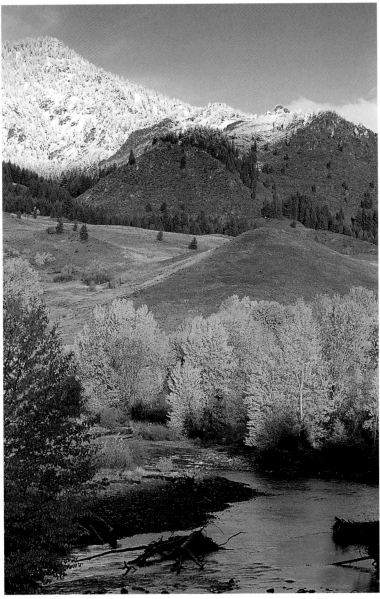

Big Wood River and Griffin Butte

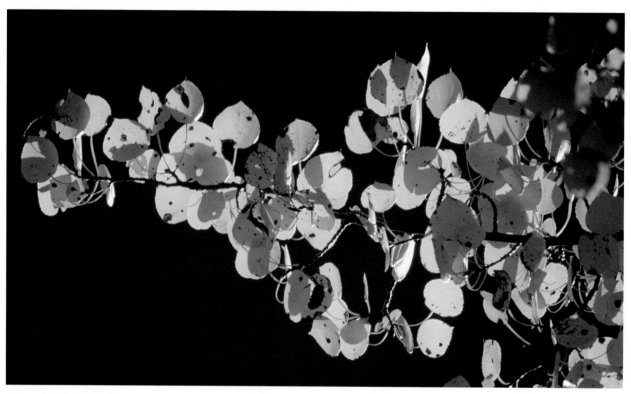

Aspens from Saddle Road

Baldy from Trail Creek

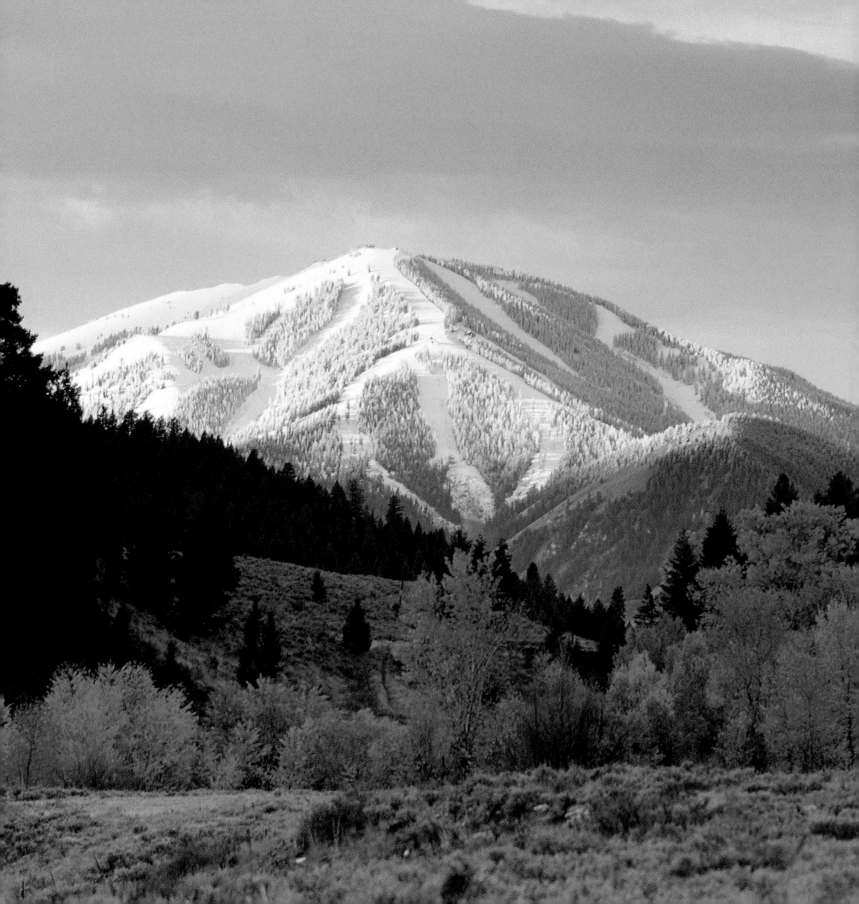

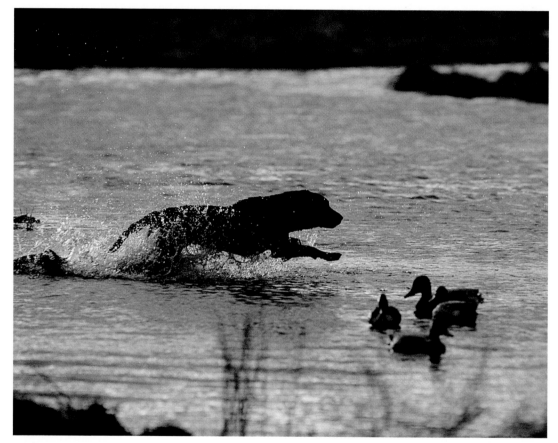

Bailey
Lost River Valley

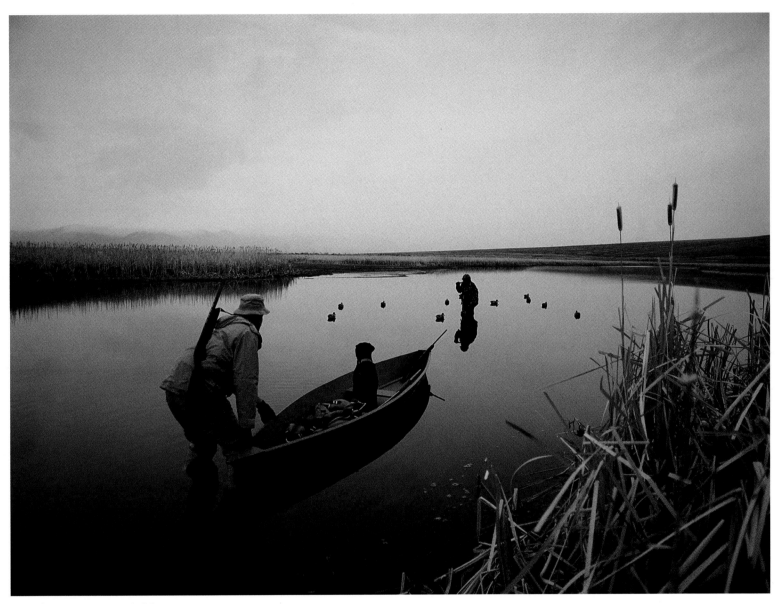

Jed Grey and Alex Higgens duck hunting
Lost River Valley

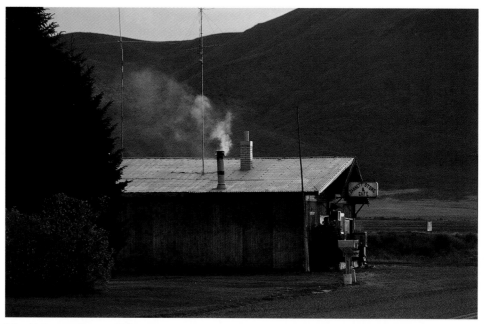

The old Gannett Country Club

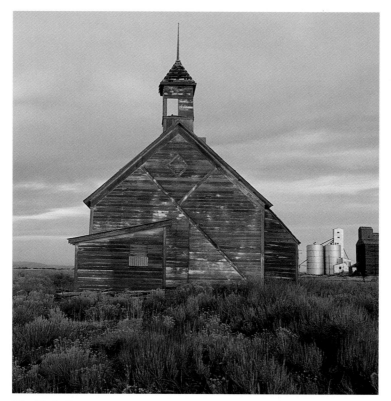

The old schoolhouse

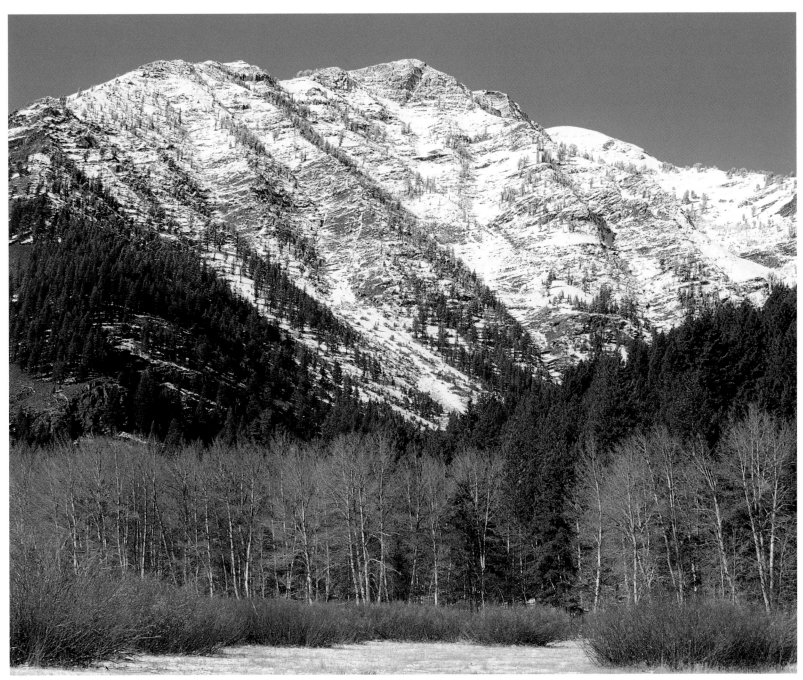

Big Fall Creek
Copper Basin

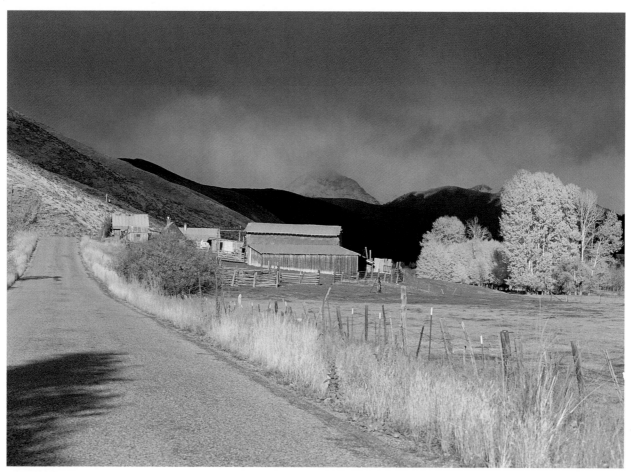

Rupert House Ranch
East Fork Road

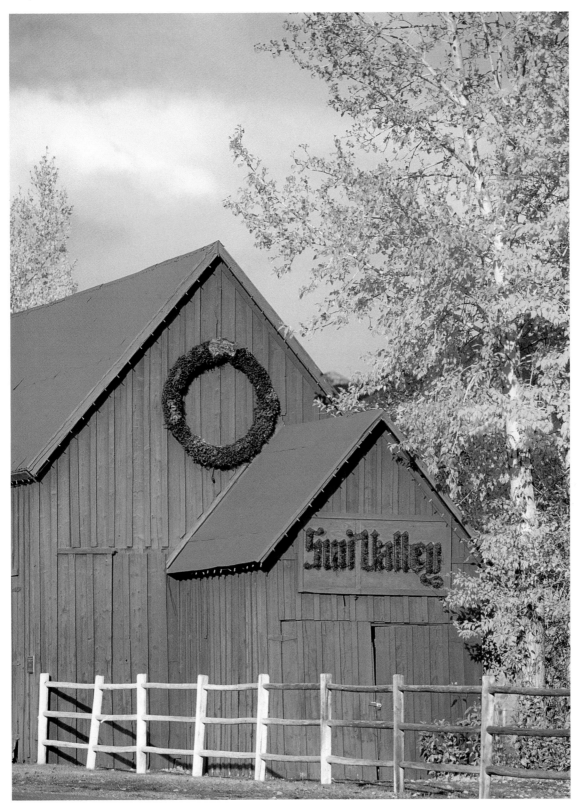

Old mill barn
Sun Valley Road

Beaver ponds
Trail Creek

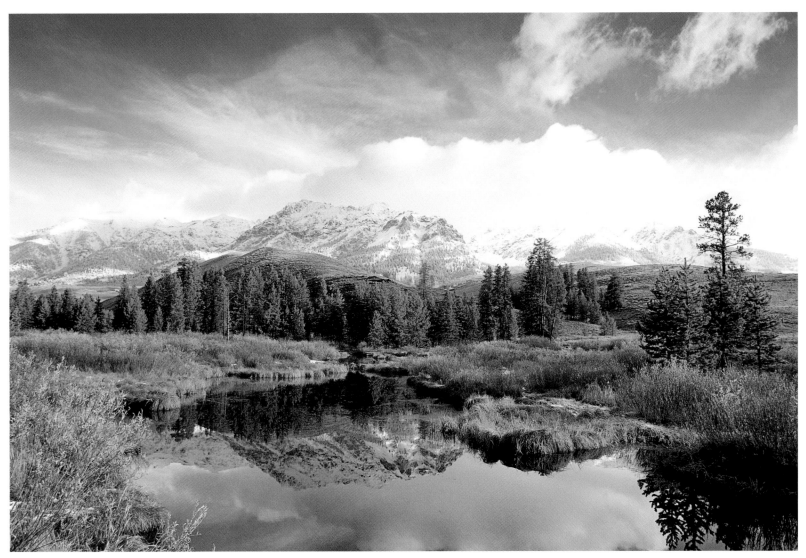

Beaver ponds
Big Wood River

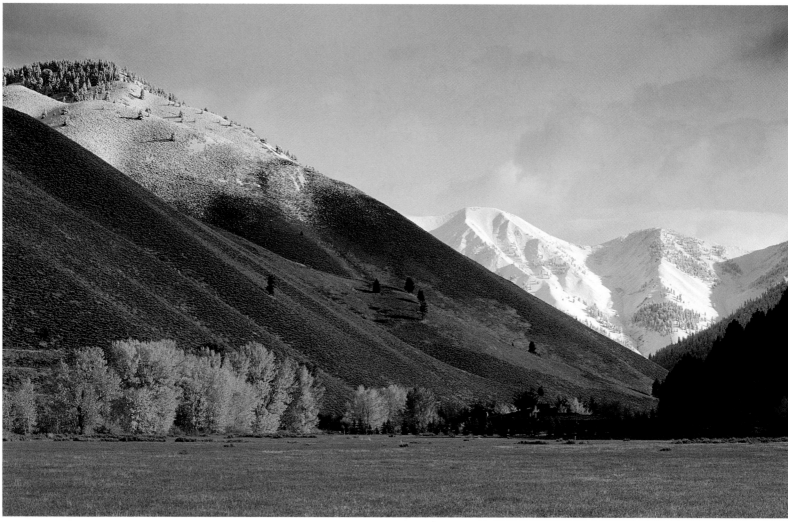

Boulder Mountains

Devil's Bedstead
Copper Basin

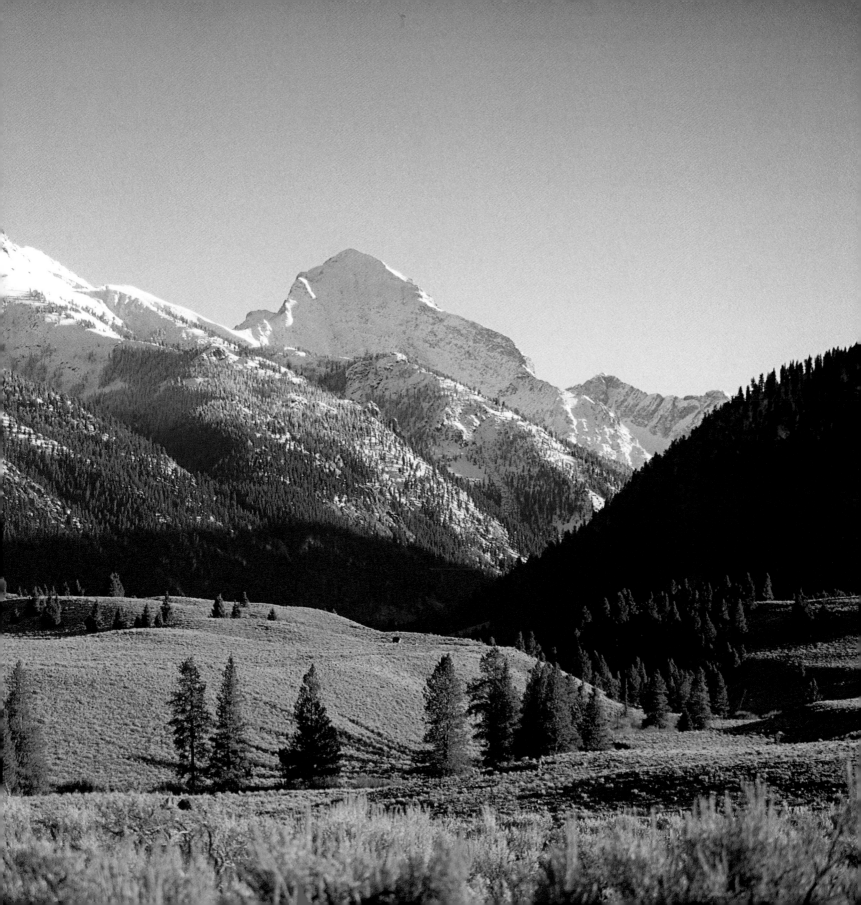

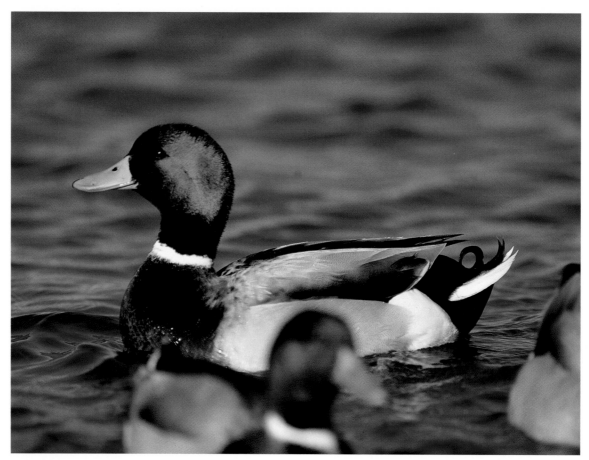

Mallard
Silver Creek

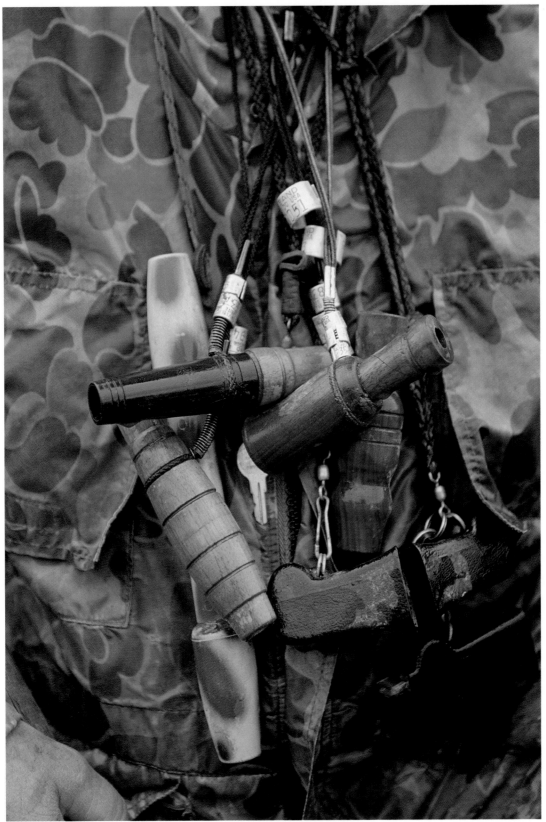

Mark Henenys
Duck calls

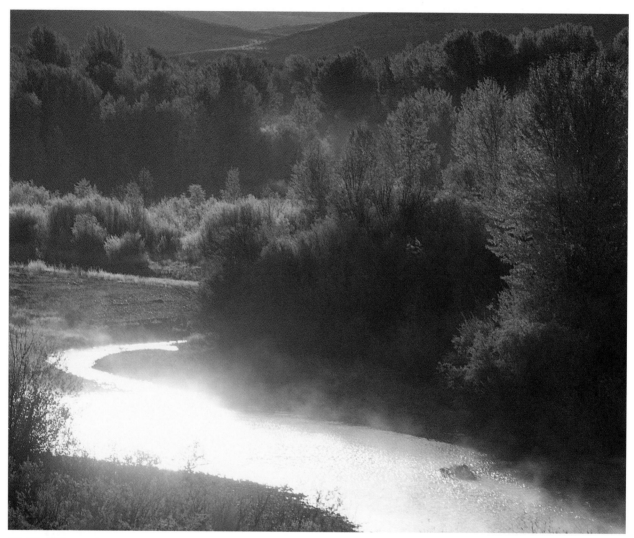

Big Wood River sunrise
Box Car Bend

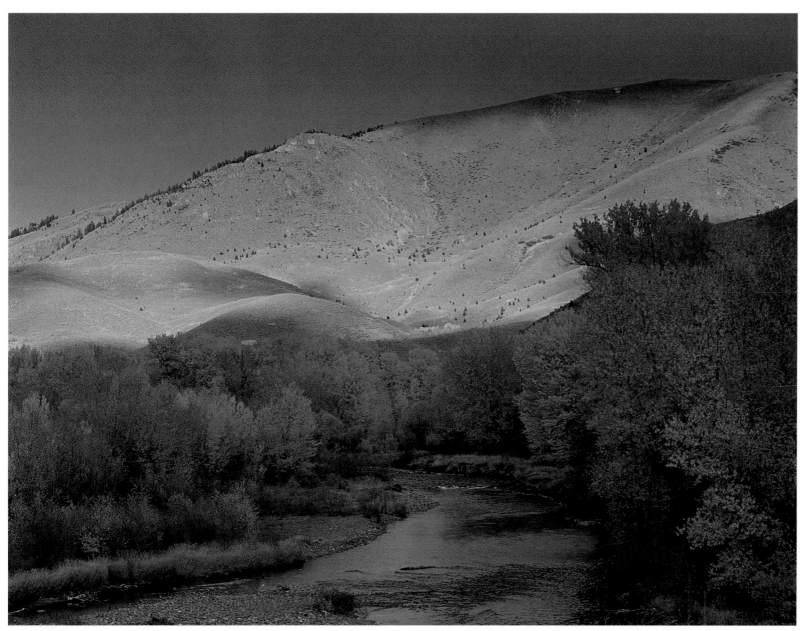

Big Wood River
Box Car Bend

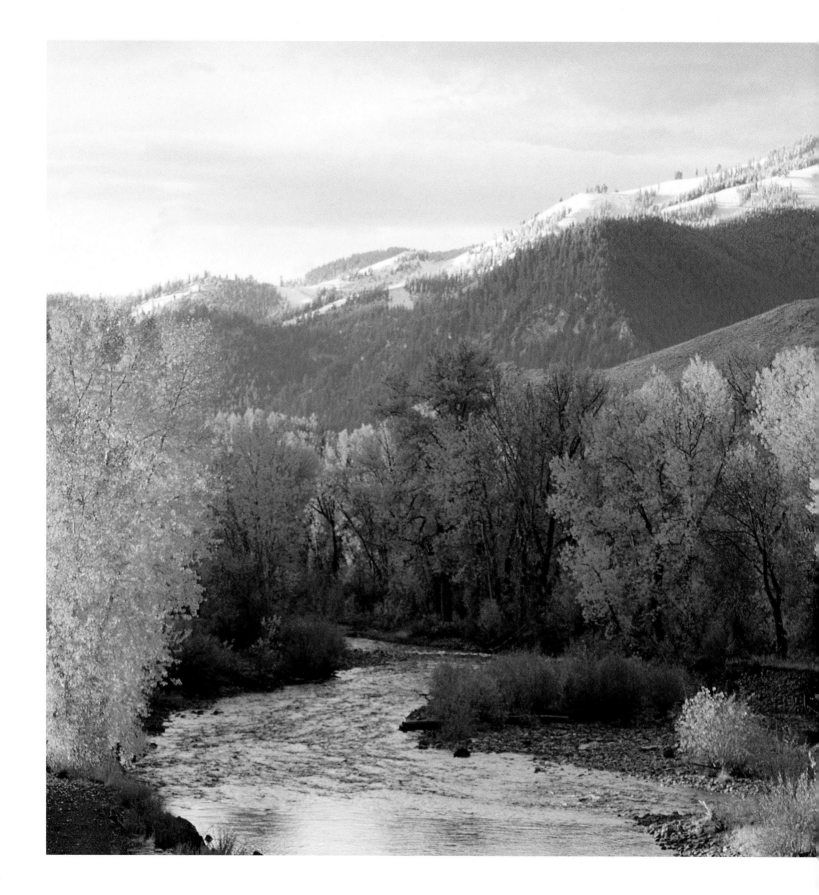

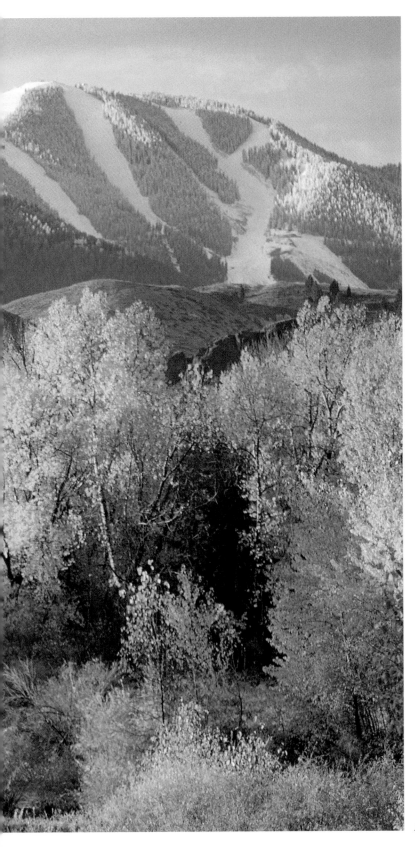

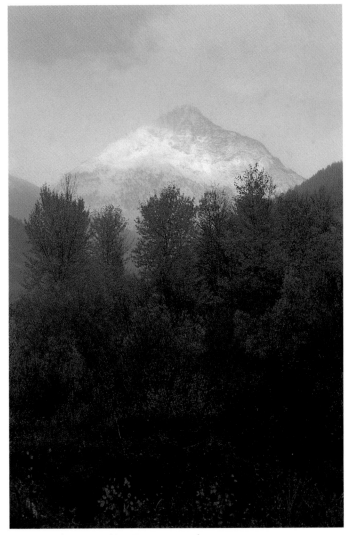

Hyndman Peak from East Fork

Baldy and Big Wood River from Hulen Meadows

115

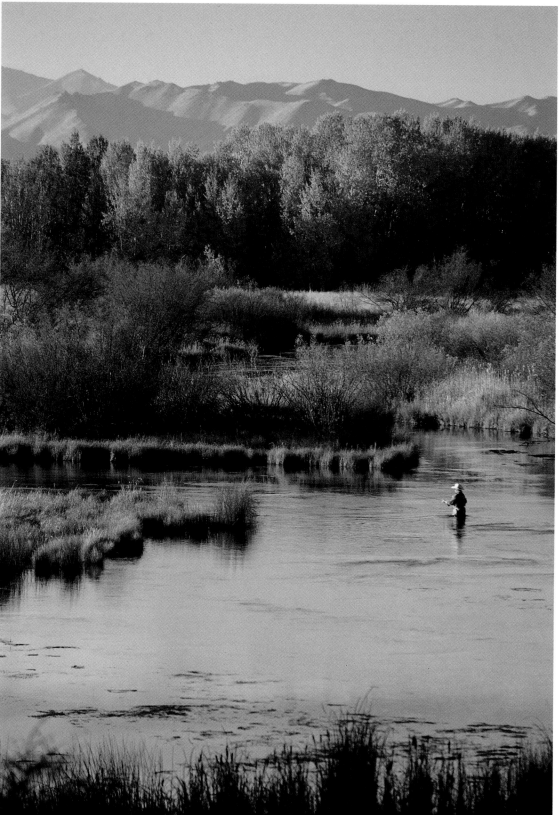

Terry Ring
Silver Creek

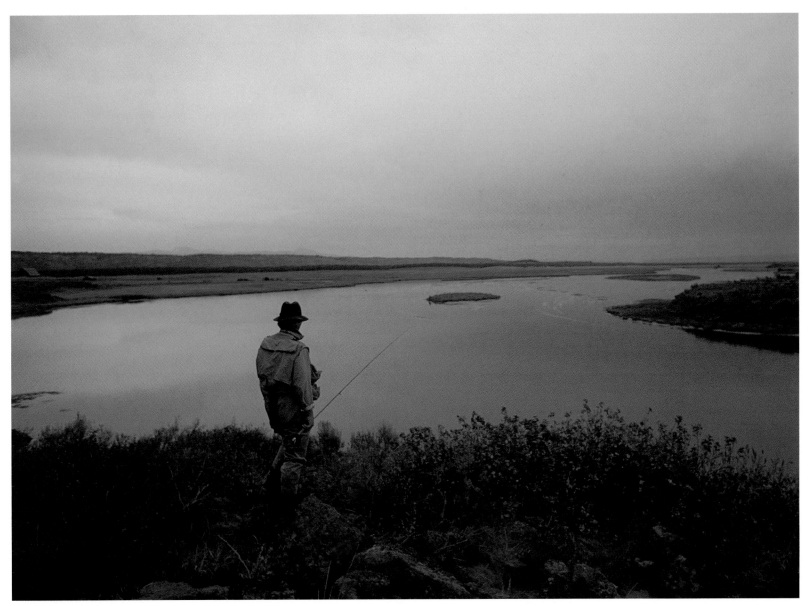

Don Hodge
Henry's Fork, Snake River

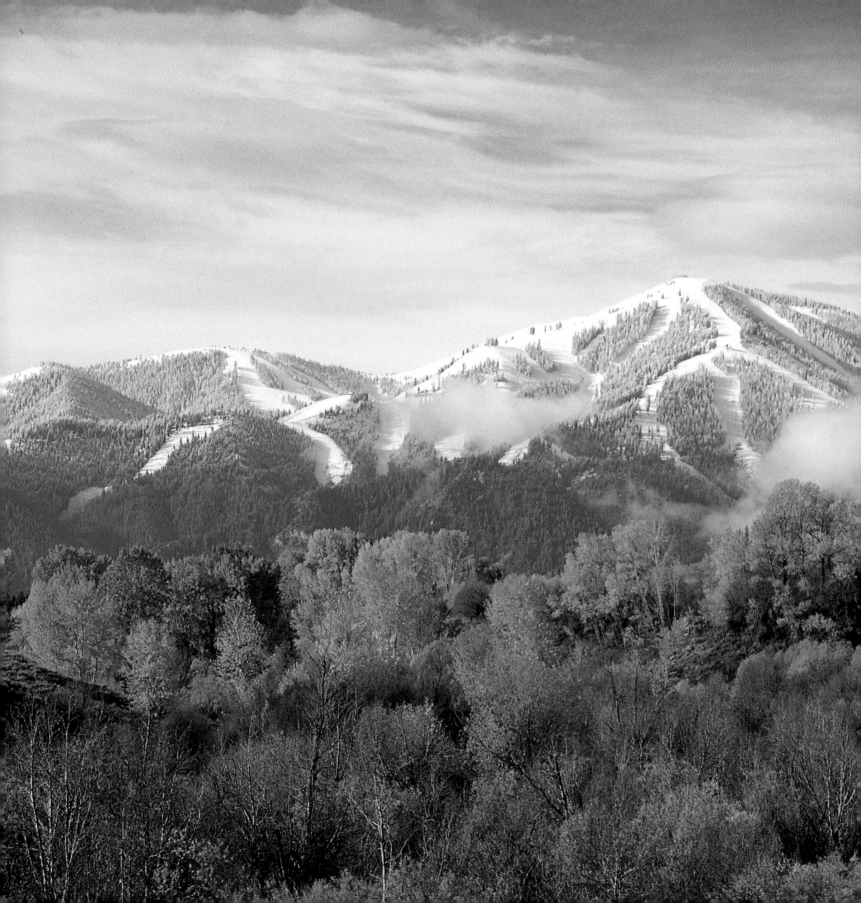

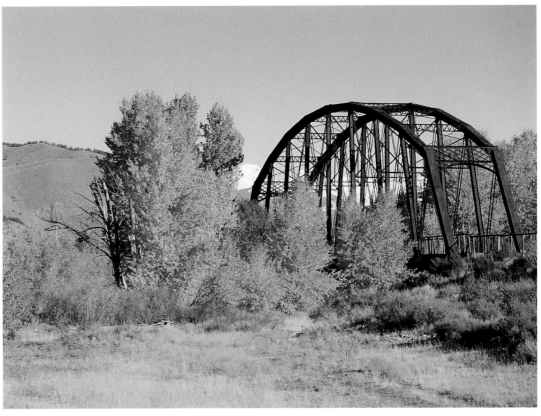

Old railroad bridge
Big Wood River

First snow
Bald Mountain

119

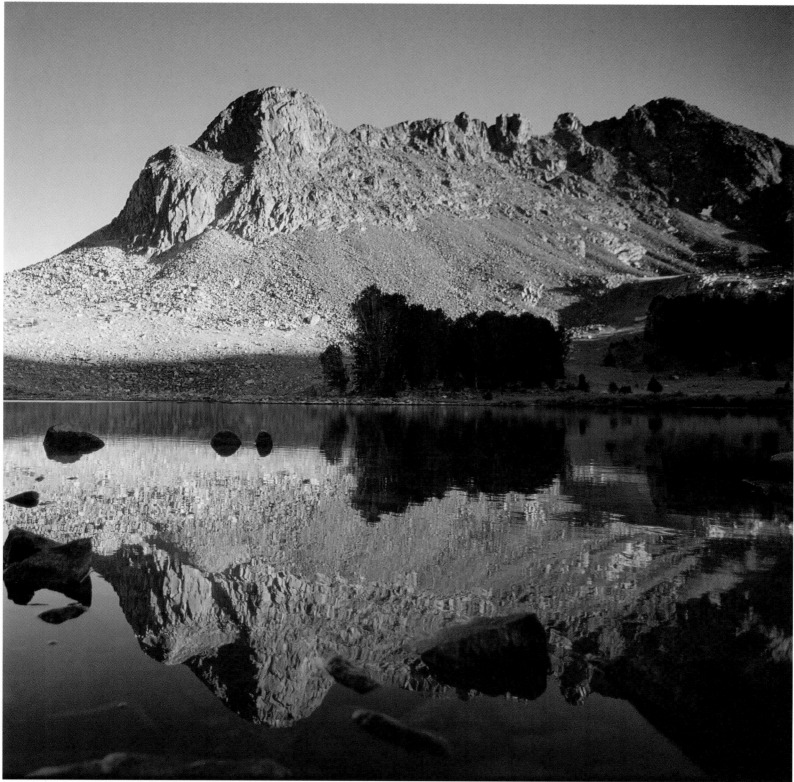

Big Lake
Copper Basin

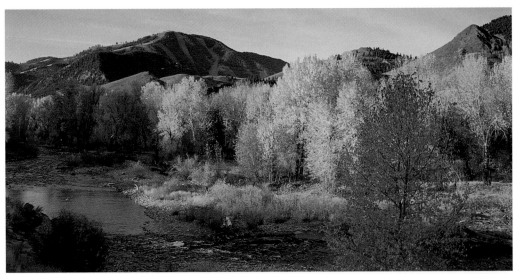

Big Wood River
Hulen Meadows

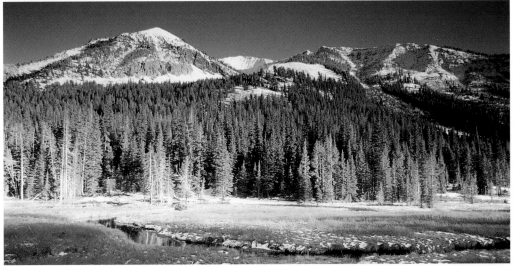

Summit Creek
Pioneer Mountains

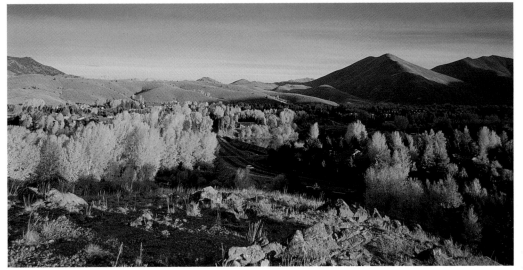

Sun Valley from
Dollar Mountain

121

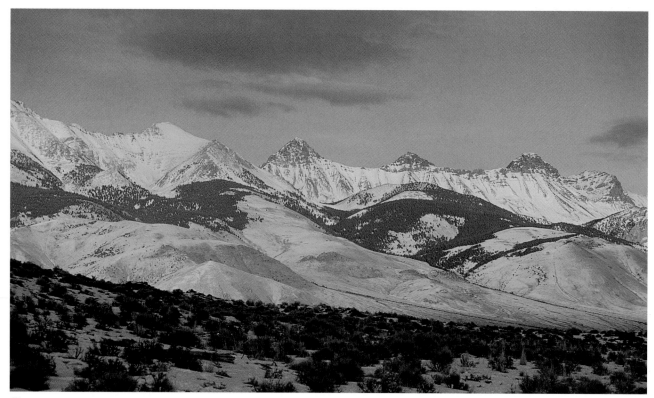

First snow
Lost River Range

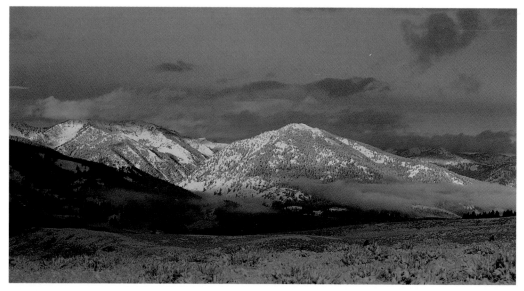

First snow
Lost River Range

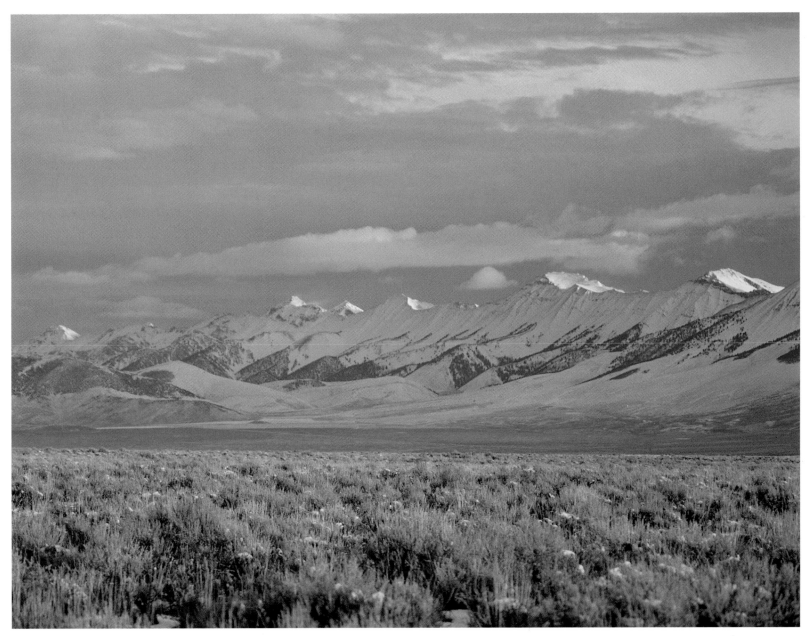

First snow
Lost River Range

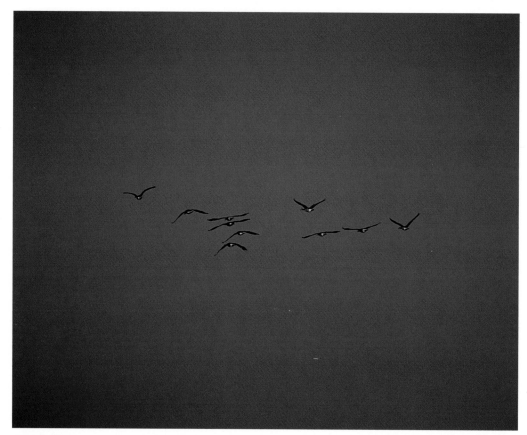

Canada Geese
Silver Creek

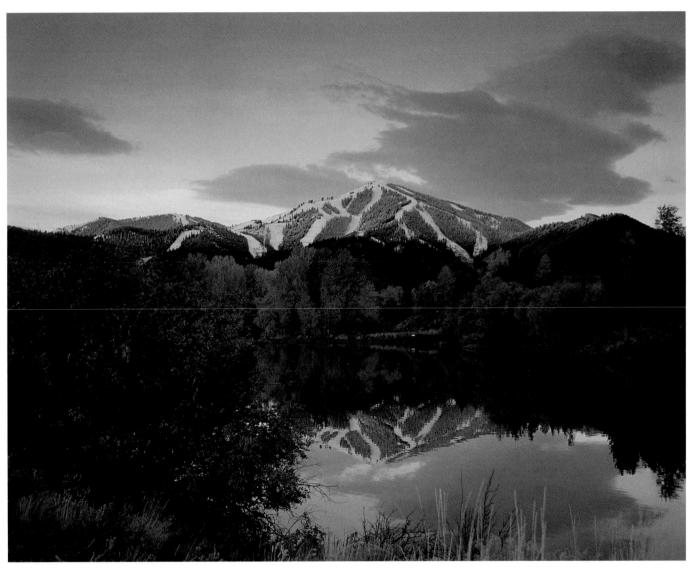

Bald Mountain from Sun Valley Lake

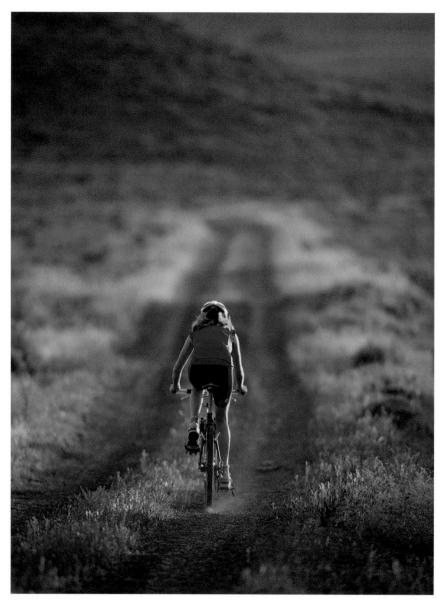

Ellie Pryor
Magic Reservoir

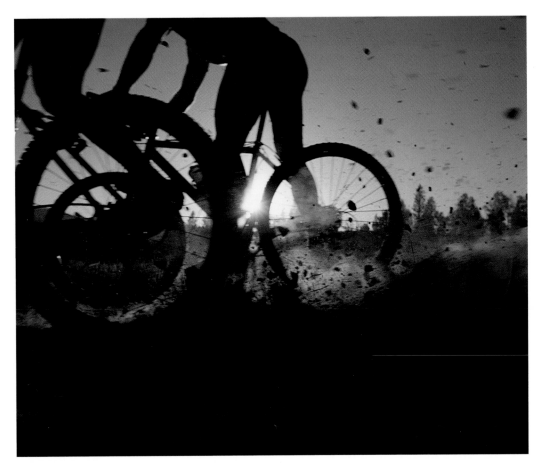

Dave Golden
Boulder Mountains

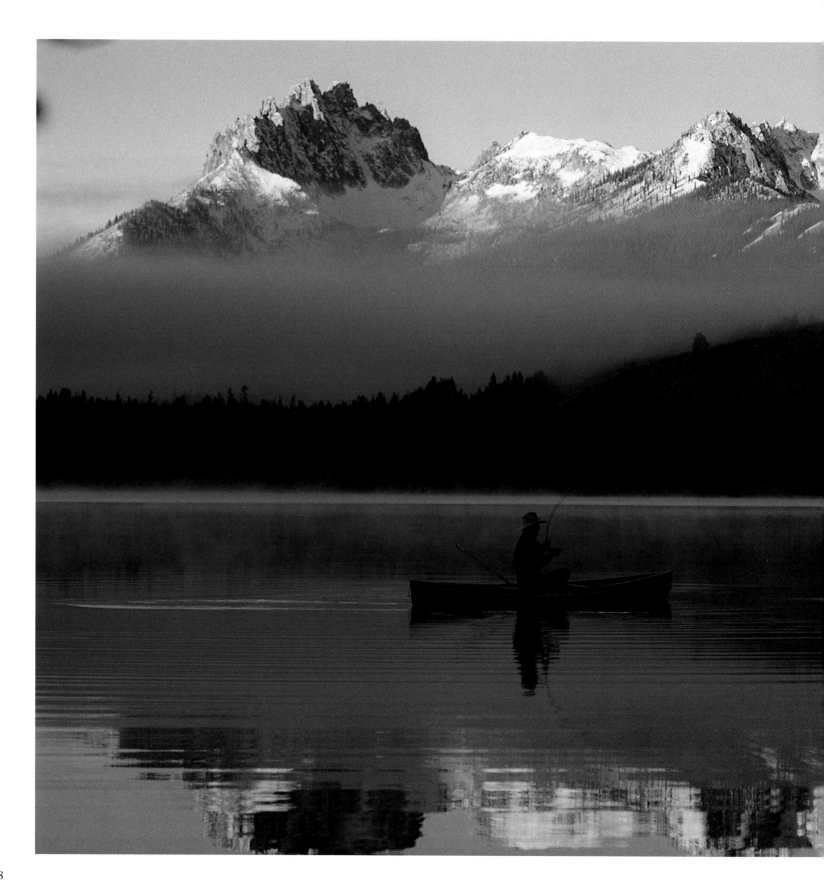

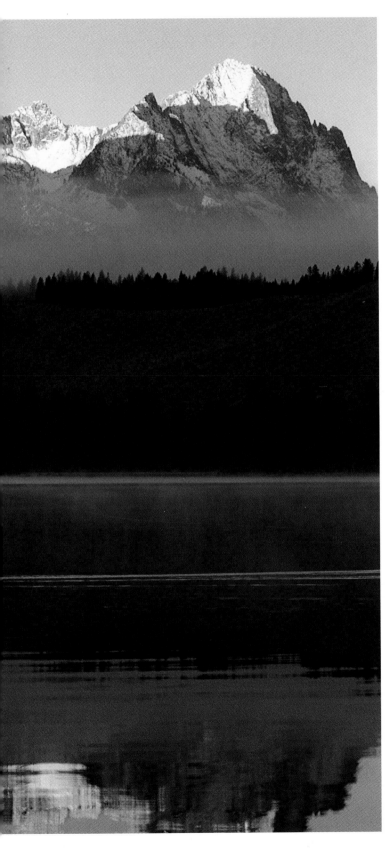

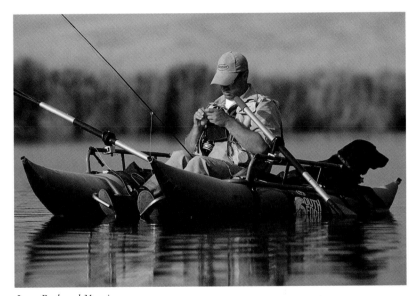

Jason Buck and Maggie
Mackay

Bill Rousey
Little Redfish Lake

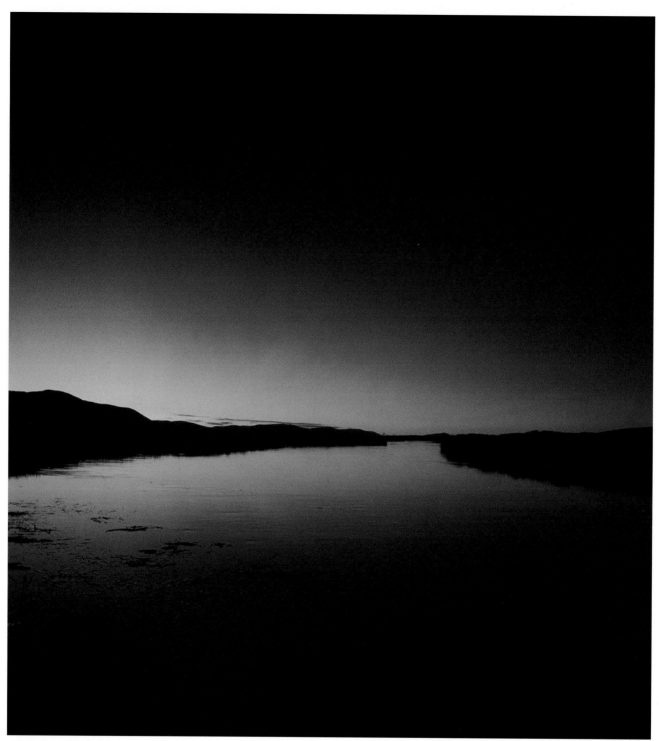

Sunset, Point of Rocks
Silver Creek

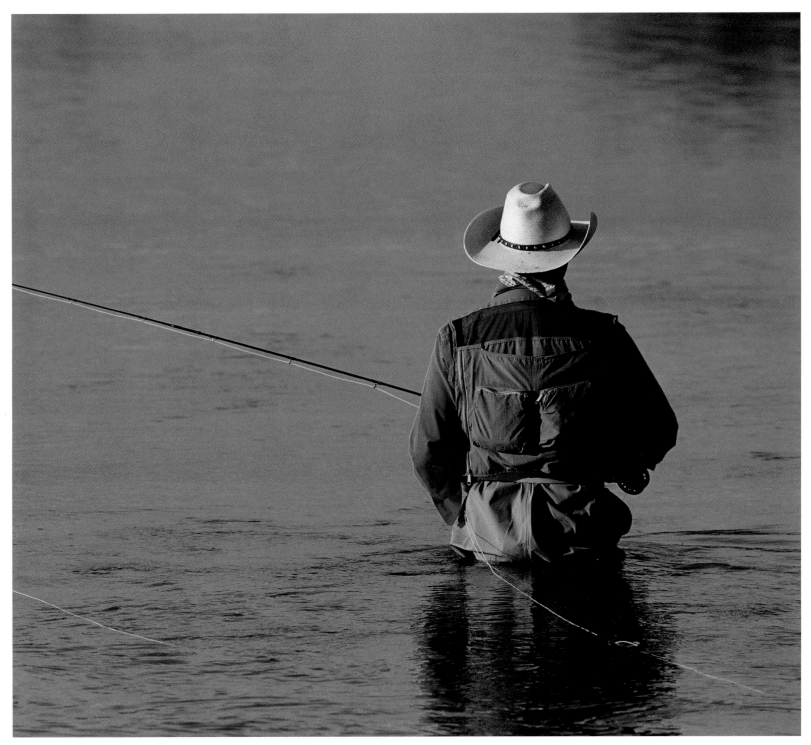

Dick Dahlgren waiting for a rise
Silver Creek

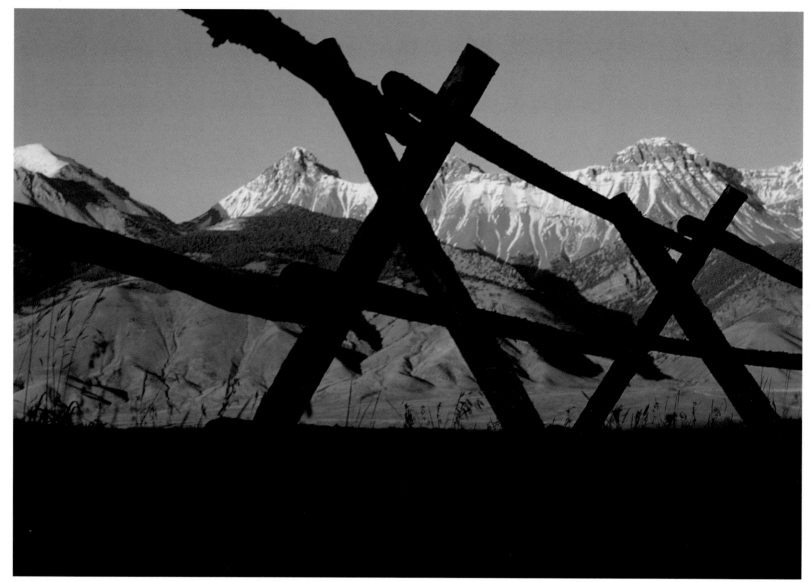

Jack fence
Lost River Range

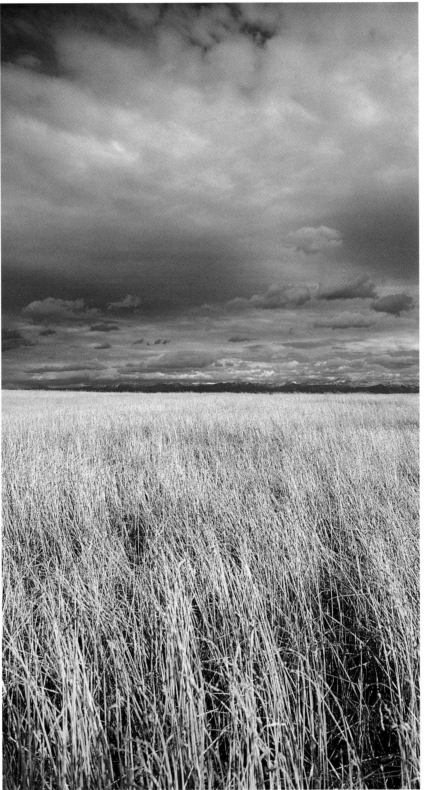

Wheat field
Fairfield

133

I hope you enjoy this collection of images from the Sun Valley area, the most wonderful place to live, work, and play. My goal was to show you, through my photos, as much as I could in this small volume. I will never quit photographing Sun Valley or enjoying it.

- David R. Stoecklein

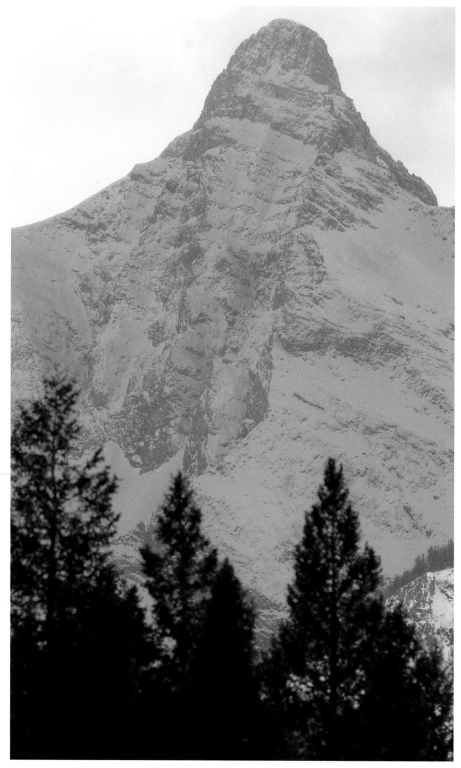

No Name Peak
Copper Basin

Technical Notes

I use Kodak film and Canon cameras and lenses for all the photography in my books and in my commercial work as well. I use a variety of different cameras from Canon, mostly the EOS 1N and the 1V. As for lenses, I use the 300mm and 400mm f/2.8L IS USM and the 16-35mm and 28-70mm f/2.8L USM and 70-200mm f/2.8L IS USM zooms. I also use prime lenses like the 20mm f/2.8 USM, 35mm, and 50mm f/1.4 USM. I use the Canon Image Stabilizer lens whenever I can, which happens to be most of the time. All of the new developments and digital innovations from Canon make my job so much easier.

All of the slide film for this project was processed at the BWC lab in Dallas, Texas. They have been processing the film for all of my books as well as the 35mm film for my regular assignments for the last thirteen years. We have a great working relationship, one that is essential in this line of work to maintain consistency and accuracy.

I am extremely lucky to have all the good people at Canon USA as a support team while I fly around the country on assignments. I would especially like to thank Mike Newler, who is always there for my assistant and me when we have questions about a special lens or a new camera. Dave Metz and Mike Newler are the team leaders at Canon and we owe them a lot for their dedication to photographers and to great pictures.

—David R. Stoecklein

Other books by David R. Stoecklein

Sun Valley Signatures I, II, III

The Performance Horse

Lil' Buckaroos

Cow Dogs

Spirit of the West

The American Paint Horse

The California Cowboy

The Idaho Cowboy

Cowboy Gear

The Montana Cowboy

Don't Fence Me In

Cowgirls

The Texas Cowboys

The Western Horse

The Stoecklein Gallery

Any of the images from this book can be ordered as a custom print in a variety of different sizes.
Please contact the gallery at 208-726-5191 or visit us online at www.stoeckleinphotography.com if you have any
questions or would like to place an order. If you ever get the chance to spend time in the
Sun Valley area, be sure to visit our gallery just north of Ketchum on Highway 75. In addition to a
selection of incredible framed fine art prints of Sun Valley and the surrounding area, we offer an
amazing collection of western memorabilia, prints, books, calendars, and cards.

Stoecklein Photography and Publishing, LLC
10th Street Center, Suite A1
PO Box 856
Ketchum, ID 83340
208.726.5191 tel
208.726.9752 fax
www.stoeckleinphotography.com

About David

David R. Stoecklein launched his career as a photographer by taking lifestyle shots of skiing, hiking, biking, fishing, tennis, and golf. That work lead to assignments for well-known companies such as Timberland, Coca-Cola, L.L.Bean, Jeep, Chevrolet, Marlboro, US Tobacco, Bayer, Pontiac, Ford, and Canon USA. His magazine clients include *Travel & Leisure, National Geographic Traveler, Western Horseman, Cowboys & Indians, Ski, Skiing,* and *Powder.*

When David moved to Sun Valley almost thirty years ago, he fell in love with the area and knew that it would be a source of lifelong inspiration for him. Since then, he has published three other photography books of Sun Valley as well as a line of western coffee-table books and calendars.

David's photography has also been featured at many prestigious museums across the country, including The National Cowboy Hall of Fame in Oklahoma, Cowboy Artists of America Museum in Texas, International Museum of the Horse in Kentucky, and The American Quarter Horse Heritage Center & Museum in Texas.

David Stoecklein resides in the Sun Valley area with his wife, Mary, and their three sons, Drew, Taylor, and Colby. They split their time between their home in Elkhorn and their ranch near Mackay.

Until we meet again...

David R. Stoecklein